IMAGES
of America

JACKSONVILLE BEACH

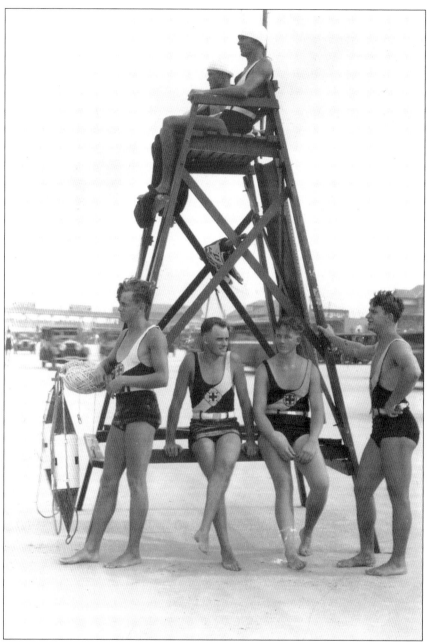

Some members of the American Red Cross Volunteer Life Saving Corps pose on a tower in Jacksonville Beach in 1926. The first corps was organized in 1912, and the organization has been praised through the years for saving many people's lives. Composed of highly trained young men who were in excellent physical condition and strong swimmers, the unique organization was the first chartered volunteer lifeguard corps in the nation. It is the only one still in existence and celebrated its 100th anniversary in 2012.

ON THE COVER: This photograph was taken during a car parade on the beach in the summer of 1951, and one of the men in the front seat of the car in the foreground is Virgil Deane, a longtime Jacksonville Beach photographer.

IMAGES
of America

JACKSONVILLE BEACH

Maggie FitzRoy, Taryn Rodríguez-Boette,
and Beaches Museum & History Park

ARCADIA
PUBLISHING

Published by Arcadia Publishing
Charleston, South Carolina

Printed in the United States of America

Library of Congress Control Number: 2013932826

For all general information, please contact Arcadia Publishing:
Telephone 843-853-2070
Fax 843-853-0044
E-mail sales@arcadiapublishing.com
For customer service and orders:
Toll-Free 1-888-313-2665

Visit us on the Internet at www.arcadiapublishing.com

This book is dedicated to the many photographers, amateur and professional, who took the pictures that appear in this book.

CONTENTS

ACKNOWLEDGMENTS

The Beaches Area Historical Society has thousands of historical photographs in its collection, which are housed in the archives of its Beaches Museum & History Park in Jacksonville Beach, Florida. Many of the images document the history of Jacksonville Beach, and this book would not have been possible without them. All images appear courtesy of the Beaches Area Historical Society.

With the help of a dedicated group of volunteers, museum archivist Taryn Rodríguez-Boette has spent countless hours organizing and scanning the original images that record the visual history of Jacksonville Beach, beginning in the 1880s. The photographs have been donated to the museum from a variety of sources; they were taken by countless amateur and professional photographers.

Journalist and photojournalist Maggie FitzRoy spent many hours going through files and boxes of photographs in order to select images for this book. She also studied archived newspapers in the museum's comprehensive collection.

Special thanks go to the museum's archive volunteers, and especially to volunteer Phyllis Haeseler, who scanned many of the photographs in this book.

INTRODUCTION

Wild dunes, wide white sandy beaches, woodlands, and scrub greeted William and Eleanor Scull when they moved in 1884 to the area in northeast Florida now known as Jacksonville Beach. They were the first official residents of a new town they helped create, and their first home was a tent near the Atlantic Ocean.

The Sculls named the town Ruby, after their young daughter, and opened a general store, also in a tent. William applied to the US government to open a post office, and Eleanor was appointed postmaster.

William was a surveyor for the Jacksonville & Atlantic Railway, which was in the process of building a 16.5-mile narrow-gauge rail line from the city of Jacksonville to the beach. The country was recovering from the Civil War, and the Industrial Revolution was creating prosperity. People from the North and South were increasingly drawn to the beach, not only as a place to relax and play, but also as a place to live.

The railroad brought people and growth, and Ruby was renamed Pablo Beach in 1885. In 1886, a grand, castle-like, oceanside resort called Murray Hall Hotel was built at the foot of what is now Beach Boulevard. It was Florida's first oceanside resort and had its own electric power plant and artesian water well.

While the Sculls were early pioneer residents of Pablo Beach, renamed Jacksonville Beach in 1925, they were not the first people to call it home. Native peoples first settled the area about 12,000 years ago.

The Timucua culture developed around 2000 BC, and the Timucua people lived in villages throughout the area. Shortly after Juan Ponce de León claimed La Florida for Spain in 1513, the Spanish built a chain of missions up and down the coast.

The Timucua people had no immunity to European diseases. The last members of the tribe left Florida in 1764. Spain distributed land grants to encourage development, and large plantations were established in the 1700s. Juan McQueen owned much of the land of present-day Jacksonville Beach, and other planters received land grants in the area.

The plantations continued to operate after Florida became a state. Land west of the beach was more valuable for agriculture because of the soil and proximity to rivers and waterways for shipping and transportation.

Murray Hall Hotel, which brought in wealthy tourists, burned down in 1890, but Pablo Beach continued to attract visitors and new residents. Spanish-American War soldiers, recovering from illnesses and waiting to be deployed, camped there in 1898 and drilled on the beach under the direction of Col. William Jennings Bryan.

In 1907, residents incorporated the town of Pablo Beach, and H.M. Shockley was appointed first mayor. By 1910, the population was 330. That year, Atlantic Boulevard, to the north in Atlantic Beach, opened and provided a way for people to travel to the beaches by automobile.

People from Jacksonville and nearby states flocked to the resort town to have fun. A boardwalk was built, as well as family-oriented guesthouses and hotels, a large roller coaster, a dancing pavilion, a fishing and dancing pier, amusements, and large bathhouses, where people could change clothes and even rent bathing suits for the day.

Growth accelerated during the Florida land boom of the 1920s, and businessmen pushed to change the name of Pablo Beach to Jacksonville Beach in 1925 to highlight its proximity to Jacksonville. They reasoned that the new name would attract even more residents and visitors. They planned to expand the boardwalk to five miles in length, but the Great Depression ended that project.

The poor economy did not stop people from going to the beach, however, and throughout the 1920s, 1930s, and 1940s, Jacksonville Beach was known as "the world's finest beach," rivaling Atlantic City, New Jersey.

Its wide beaches with hard-packed sand were perfect for driving on, and people loved to do just that. On weekends in the summer, beachgoers parked in neat, orderly rows from the boardwalk almost to the ocean's edge.

With so many people frolicking in the ocean, the town's American Red Cross Volunteer Life Saving Corps prevented many from drowning—members were considered the heroes of the day. The first lifeguard corps was founded in 1912, making it the nation's first chartered volunteer lifeguard corps. It operated out of a small station at the foot of present-day Beach Boulevard, near the train station, and through ensuing years larger stations replaced the first small shack. The corps continually attracted brave young men, and later women, from throughout the Greater Jacksonville area and celebrated its 100th anniversary in 2012.

As a summer resort destination, Jacksonville Beach attracted not only many visitors but also an increasing number of people who chose to live there year-round. Elementary school–age children attended a schoolhouse in town, and in 1924 a new, two-story modern school was built for them. To attend high school, students needed to travel into Jacksonville until the late 1930s, when Fletcher High School was built.

Due to segregation of Southern schools, African American children attended a separate elementary school and also had to travel into Jacksonville to attend a different high school until desegregation allowed them to attend Fletcher High in the late 1960s.

African American residents lived in a small community southwest of Jacksonville Beach's downtown in a slightly elevated area known as "The Hill." The community had its own thriving businesses and churches.

Development slowed during the Great Depression, as it did in the rest of the country. In 1931, while participating in a "tax revolt," residents in the northern part of Jacksonville Beach split off and incorporated the new town of Neptune Beach.

In 1932, the Florida East Coast Railroad, which had taken over the original railway, discontinued service. The automobile was becoming the preferred mode of transportation, and people drove to Jacksonville Beach on Atlantic Boulevard until Beach Boulevard opened in 1950. It was built on the site of the original railroad.

During the late 1930s and during World War II, the development of Naval Air Station Jacksonville meant the construction of support facilities, including Naval Station Mayport, north of Atlantic Beach, which was commissioned in 1943. Also, more residents and businesses arrived in Jacksonville Beach. The area continued to grow after the war, and new homes and schools were built.

The town continued to attract visitors looking for family-friendly fun in the sun through the 1950s and 1960s, although tourists were increasingly drawn to beaches farther south and, later, to Disney World and other parks in Orlando.

Hurricane Dora destroyed many homes and businesses in 1964, and the times also altered the town. People did not need bathhouses any more. The Ferris wheel was dismantled. Laws were passed prohibiting driving on the beach. Some condominiums replaced mom-and-pop motels.

But, Jacksonville Beach is still a place for people looking for a fun time. It is a place where they can take a break from the chores of life and play by the sea. It is still a place to relax on wide white beaches and swim and splash in the surf.

One

PABLO BEACH

When William and Eleanor Scull moved from Jacksonville to the beach in October 1884, they first lived in a tent that faced present-day Beach Boulevard between Second and Third Streets. About a dozen other families also lived nearby in tents, and their new town, called Ruby, was accessible only by water. People had to travel down the St. Johns River to Mayport and then up San Pablo Creek, now the Intracoastal Waterway. From there, they had to walk two miles through palmetto scrub. Mail arrived from Mayport once a week.

The Sculls completed building their 10-room house the next year, which was also when the name of the growing town was changed to Pablo Beach. The narrow-gauge railroad from Jacksonville was completed, and with regular passenger and freight service people started buying lots from the railroad company and moving there.

Gen. Francis E. Spinner, who served as US secretary of the treasury during the Civil War, bought one of the first lots. He erected a large tent home on the property, which overlooked the beach, and called it Camp Josephine.

Entrepreneur John Christopher, owner of the railway, built the grand, oceanfront Victorian Murray Hall Hotel in 1886. The winter and summer resort was six stories, and 15-foot-high porches extended along every floor. It had steam heat, electricity, 58 fireplaces, and elaborately landscaped grounds. Featuring dormered gables, a curved veranda, and an enormous central tower, it was considered the most attractive resort on the Atlantic coast.

When Murray Hall, which was underinsured, caught fire and burned to the ground in August 1890, Christopher sold his Jacksonville & Atlantic Railway to Henry Flagler's Florida East Coast Railway. Flagler extended the line north to his grand Continental Hotel in Atlantic Beach and Mayport.

After Murray Hall was destroyed, Pablo Beach grew as a resort destination that attracted middle-class and working families rather than very wealthy visitors. They stayed in lodges, cottages, rooming houses, and small hotels and motels. Those who could only afford to come for the day via train changed their clothes in the bathhouses that sprang up next to a boardwalk along the dunes.

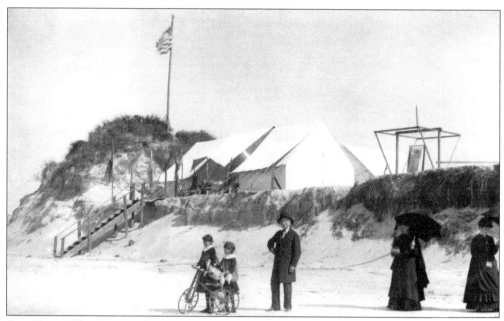

Gen. Francis Elias Spinner, former secretary of the treasury during the Civil War, poses (center) with family members and friends in 1885. His tent compound at Pablo Beach, seen in the background, was called Camp Josephine.

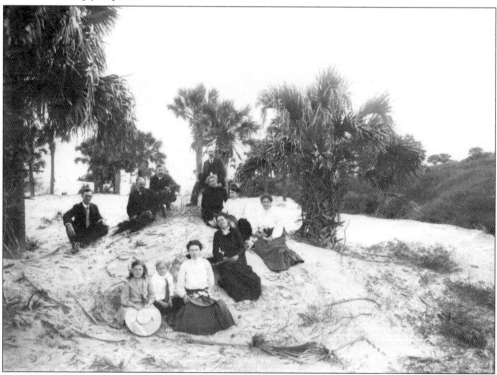

Here, people relax on a sand dune in Pablo Beach around 1900. This photograph shows what the beach looked like before development. The sand dunes that framed the beach were later flattened to build homes, businesses, and the boardwalk.

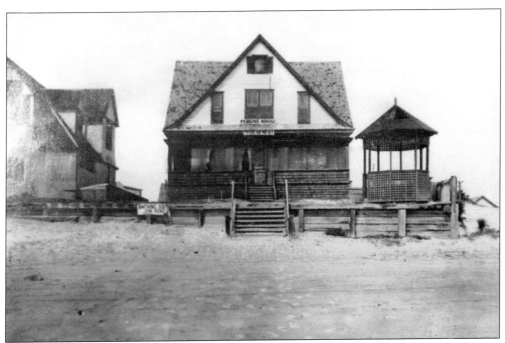

This is the Perkins House, a popular oceanfront boardinghouse at North First Street, in 1900. The sign to the left says, "Bathing suits for rent." At that time, many people did not own their own bathing suits, so they rented one for the day or for the length of their stay at the beach.

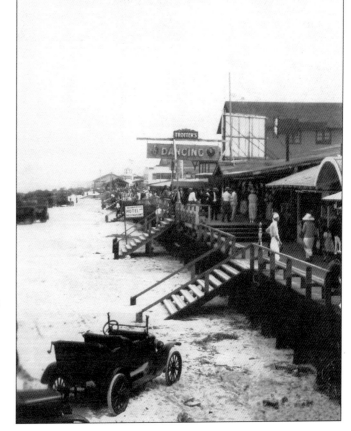

Pictured looking south in the early 1900s is one of the first boardwalks in Pablo Beach. Trotter's Dance Pavilion was a popular spot on the boardwalk. In newspaper advertisements, the business urged people to tell friends "meet me at Trotter's."

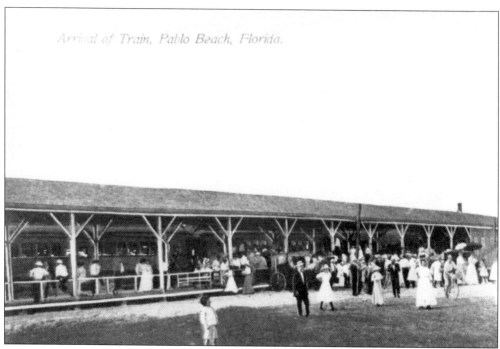

Arrival of Train, Pablo Beach, Florida.

A train from Jacksonville pulls up at the Pablo Beach depot one day in the early 1900s. Passengers can be seen waiting for the train, which was a 40-minute ride from the beach to the city.

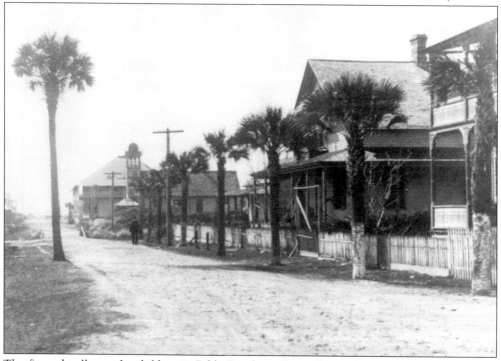

The first schoolhouse for children in Pablo Beach was located on Palmetto Avenue. A one-story wooden building that served children of all ages, the schoolhouse was located at the end of the road. When this photograph was taken in 1906, there were few children living year-round in town.

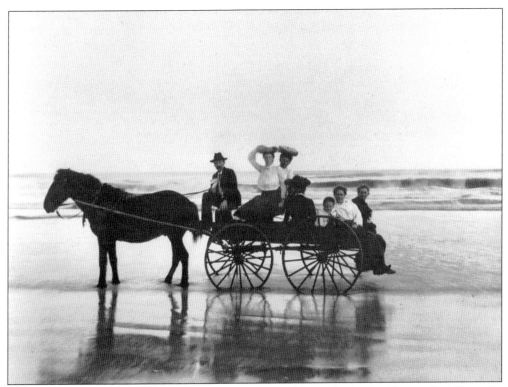

The first mayor of Pablo Beach, Henry M. Shockley, and his wife, Ottillia Knauer Shockley, take a horse-and-buggy ride along the tide line with friends and family members in the early 1900s. Shockley became mayor in 1907.

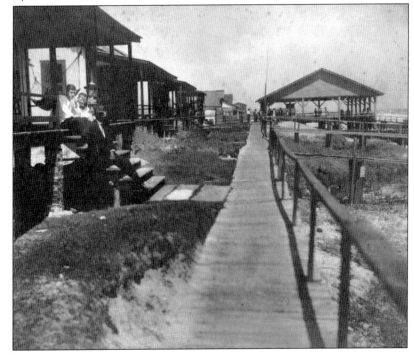

A group relaxes on the steps in front of city hall in 1907 in Pablo Beach. The boardwalk at that time was very narrow and not yet the wide promenade it would become.

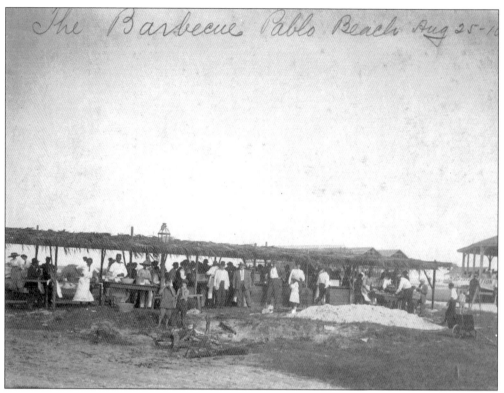

The Barbecue Pablo Beach Aug 25-10

A large group of beachgoers enjoys a barbecue on August 25, 1910, in Pablo Beach. Nothing more is known about this gathering, but it looks like everyone is having fun.

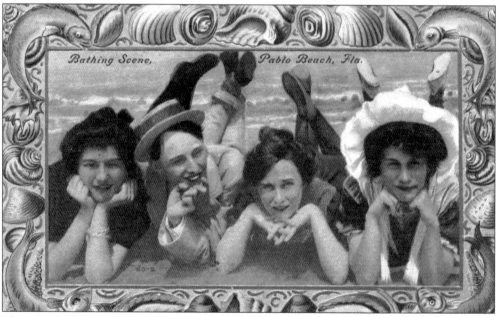

Bathing Scene, Pablo Beach, Fla.

This 1910 bathing scene in Pablo Beach was made into a postcard. The man is dressed in street clothes, but the women are dressed in bathing suits of the period, which included hats, hose, and beach shoes.

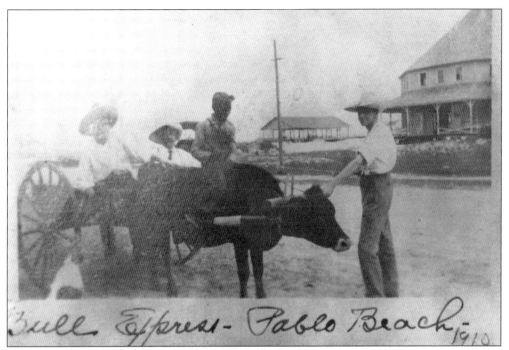

Early residents of Pablo Beach get around town on the "Bull Express" in 1910. Roads and conditions were primitive in those days, and although Atlantic Boulevard opened that year to provide automobile access between Jacksonville and the beach, very few people had cars.

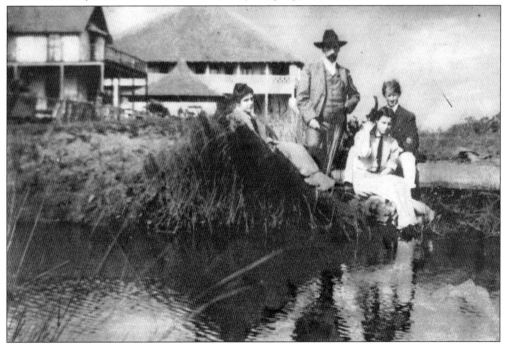

Early Pablo Beach resident Anna Purcel (far left) enjoys a day in the sun in 1911 with friends. They are relaxing on the corner of Second Avenue South and First Street at what was then Bonsall Creek. The Hotel Pablo is in the background.

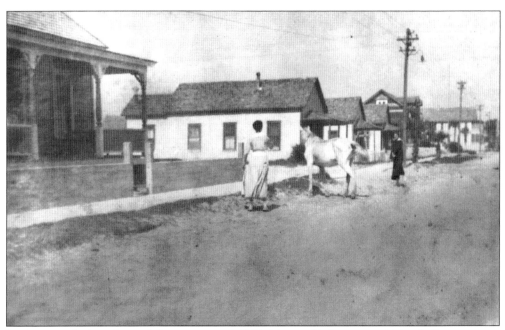

Looking north from Second Avenue around 1911, Minnie Dickinson and Maude Bowen try to catch a horse at First Street. At that time, the roads were unpaved in Pablo Beach.

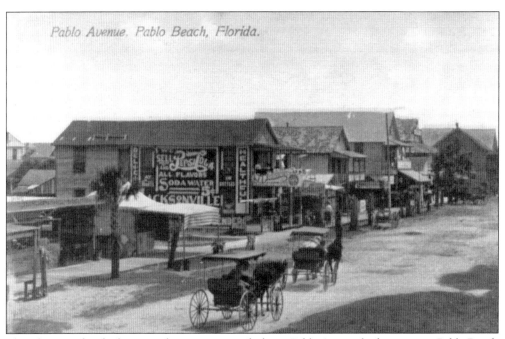

This photograph, which was made into a postcard, shows Pablo Avenue looking east in Pablo Beach in 1911. The roads were unpaved, and most people still traveled by horse and buggy.

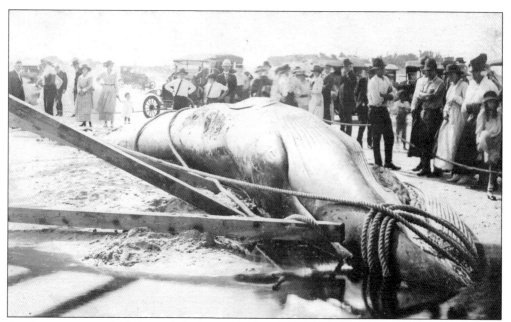

Beachgoers surround a baleen whale that washed up on Pablo Beach around 1912. Nothing more is known about the incident, but the candid photograph shows the types of clothing people wore at the time.

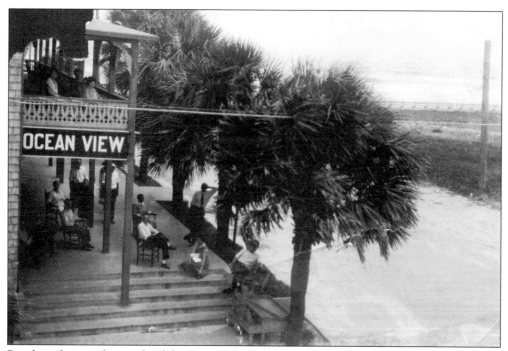

People gather on the porch of the Ocean View Hotel, located on First Street North and Pablo Avenue. The popular hotel had 50 rooms. This photograph was taken in the first part of the 20th century. The hotel opened in 1914 and burned down in 1926.

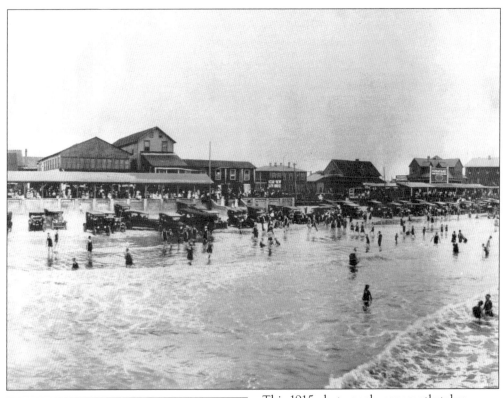

This 1915 photograph, apparently taken from a boat, is of Pablo Beach's boardwalk and oceanfront; beachgoers are seen enjoying the beach. Most people took the train from Jacksonville to get to the beach, but the people who owned cars loved to drive them onto the beach.

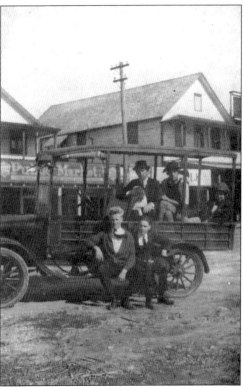

A group of men and boys poses on a station wagon in front of Public Market on Pablo Avenue in 1915.

Here, a couple waits for a buggy ride to begin on Pablo Beach in 1917. At that time, people were transitioning from the horse and buggy to the automobile.

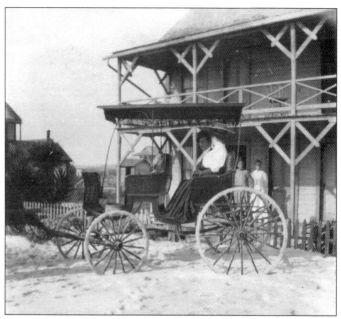

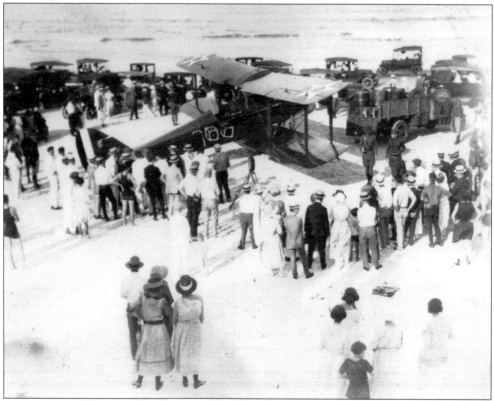

Crowds surround Army lieutenant James H. Doolittle on September 4, 1922, as he gets ready to take off from the beach in Pablo Beach to fly to San Diego, California. He flew a de Havilland DH-4 biplane and made the trip in less than 24 hours with one fuel stop in San Antonio, Texas. His feat established a new speed record and helped demonstrate the practicality of transcontinental flight.

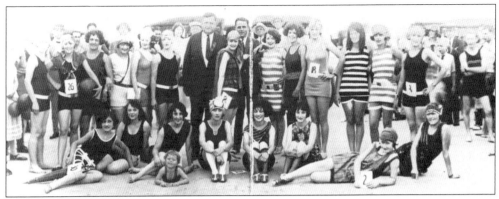

Pablo Beach bathing beauties pose for a panoramic photograph on June 5, 1924. Note the different types of bathing suits popular at that time. Though not noticeable in this black and white photograph, bathing suits came in a wide variety of colors. A *Pablo Beach News* reporter in 1923 wrote, "Bathing suits are a kaleidoscope of color, far out dazzling the brilliancy of the rainbow. That is the sight that greets the onlooker from either the beach promenade or the boardwalk."

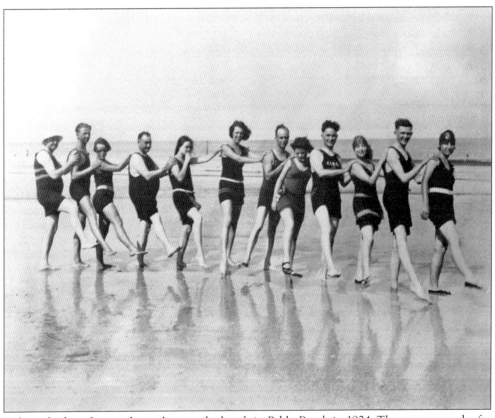

A dozen bathers form a chorus line on the beach in Pablo Beach in 1924. The woman on the far right is identified as Ellen Smith.

Two

LIFEGUARDS

Bathing in the ocean was sometimes dangerous in the early part of the 20th century. Many people did not know how to swim, and there were frequent deaths caused by drowning, and people who were poor swimmers often tried to rescue others in distress and died trying. The closest hospital was 25 miles away, which added to the problem.

To protect beachgoers, the first lifeguard corps in Pablo Beach was founded in the summer of 1912 as the US Volunteer Life-Saving Corps. Two years later, the corps joined the American Red Cross organization and changed its name to the American Red Cross Volunteer Life Saving Corps. It was composed of trained young men who volunteered to guard the beaches during holidays and weekends.

The unique corps was the first volunteer lifesaving organization in the country, was considered the most distinguished in the nation, and is the only one that survived into the 21st century—celebrating its 100th anniversary in 2012.

In 1920, a larger station with a high tower replaced the first station, a wooden shack at the foot of present-day Beach Boulevard. The 1920 station was replaced in the late 1940s with the white stucco Art Deco–style station that still stands today as a Jacksonville Beach landmark.

A Women's Life Saving Corps was founded to assist the men's organization in 1922. The women were highly trained, like the men, and were excellent swimmers. Some competed in long-distance swim meets around the country. They also gave free swimming lessons to the public.

Local newspapers praised the lifeguards. "A warm welcome is sure to greet the men upon their appearance" on the beach, stated a March 25, 1922, article in the *Pablo Beach News*. "They are a fine body of upstanding young men, gentlemen in every sense, capable and conscientious."

An August 1928 article in *Beach Life* gave "a hint to the public: If you find yourself drowning do not fear for your safety if you are within hearing of a Girl Life Saver. In fact, a good many folks would find it rather pleasant to be rescued by a fair young Red Cross girl."

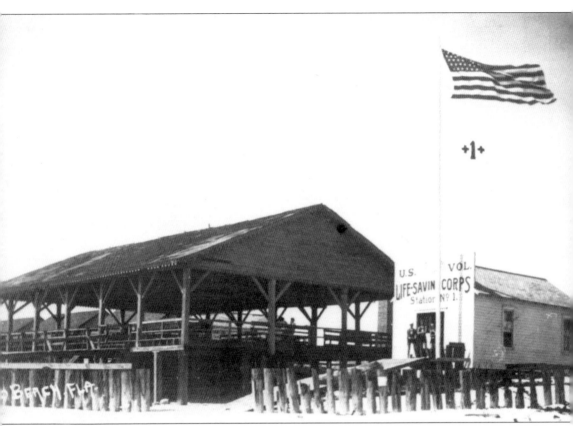

This is a photograph of US Volunteer Life-Saving Corps Station No. 1 in Pablo Beach in 1912, the year it was founded. Lifeguards operated out of the small wooden shack overlooking the ocean at what is now the foot of Beach Boulevard. The corps joined the American Red Cross in 1914 and became the American Red Cross Volunteer Life Saving Corps.

Charter members of the US Volunteer Life-Savings Corps pose for a photograph in early 1913 in Pablo Beach. They are, from left to right, (sitting) unidentified, George Coslow, ? Ironmonger, Charles Noble, and Truscott Copp; (kneeling) Pat Crawley, ? Burroughs, ? Miller, and ? Berg; (standing) Arthur Burroughs, Ed Moylan, ? Simpson, ? Washburn, Lt. Oscar Schubert, ? Nearpass, and Arthur Pine.

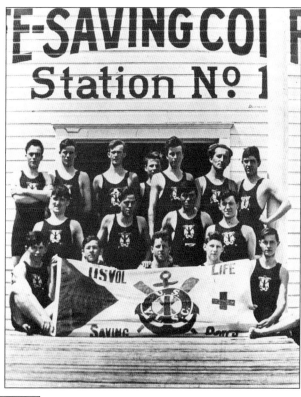

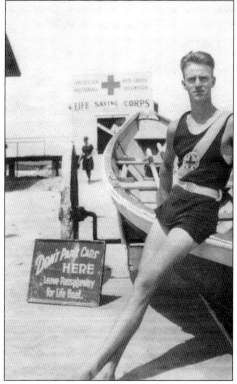

American Red Cross Volunteer Life Saving Corps lifeguard Neal Brock is ready with a surf lifesaving boat in front of the station in Pablo Beach in 1919. The first lifeguard corps in the city was organized in 1912. Considered brave, upstanding young men, the guards were praised for being heroes.

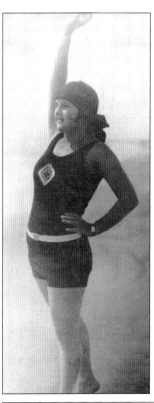

A member of the Women's Life Saving Corps poses for a picture in the 1920s. Also excellent and strong swimmers, women lifeguards assisted men. Many competed in long-distance swim meets around the country.

Ernest Porter, a lifeguard with the American Red Cross Volunteer Life Saving Corps, poses in front of his car with his dog in 1925. Porter was a well-known and admired lifeguard who won medals for rescuing people in the ocean.

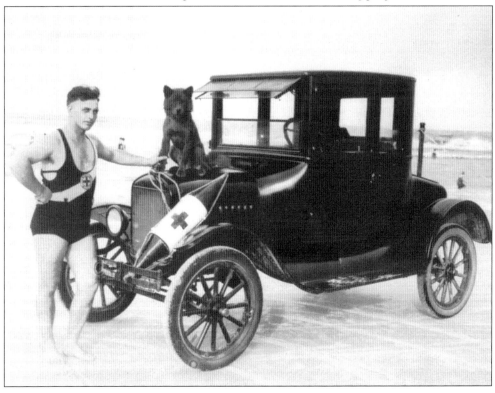

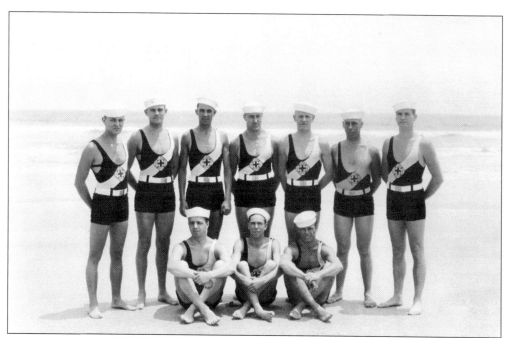

This is a photograph of the American Red Cross Volunteer Life Saving Corps staff officers in 1925. They are, from left to right, (sitting) Edward Law, James Dover, and Allen P. Hogan; (standing) Earl G. Marx, Robert Glover Weiss, Ted Hoffner, Harold Duguid, Robert C. Peek, John J. O'Rourke, and James Rae Simpson.

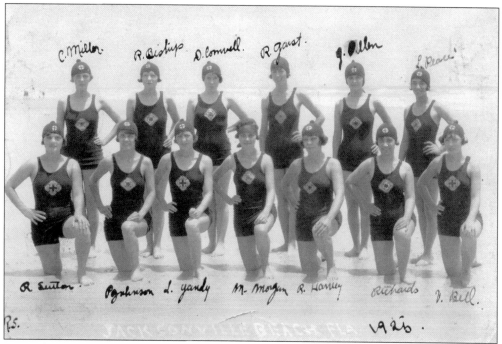

Women's Life Saving Corps members pose for a picture in 1925. They are, from left to right, (first row) R. Sutton, P. Johnson, L. Gandy, M. Morgan, R. Haney, P. Richards, and V. Bell; (second row) C. Miller, R. Bistrip, C. Cromwell, R. Garst, J. Allen, and L. Peace.

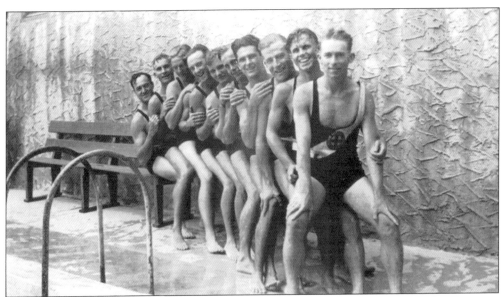

Ten American Red Cross Volunteer Life Saving Corps lifeguards pose for a photograph in Daytona Beach on October 26, 1926. The lifeguards traveled to showcase their skills and compete with other guards around the state.

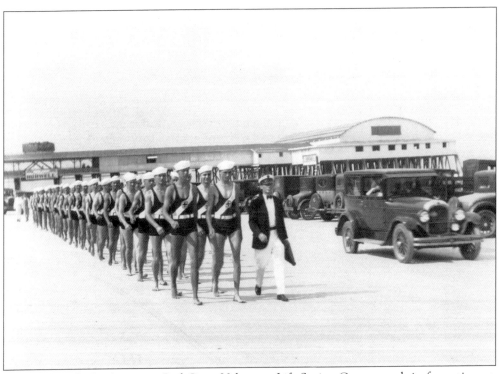

Lifeguards with the American Red Cross Volunteer Life Saving Corps march in formation on the beach in Jacksonville Beach in 1926. Behind them is Shad's Pier, which was a dancing and fishing pier.

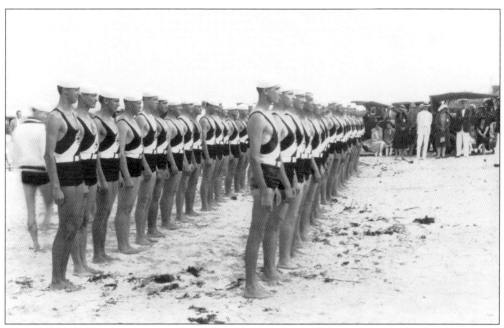

As spectators look on, American Red Cross Volunteer Life Saving Corps lifeguards stand in formation on the beach in Jacksonville Beach in 1926. Some of the spectators are standing next to their cars.

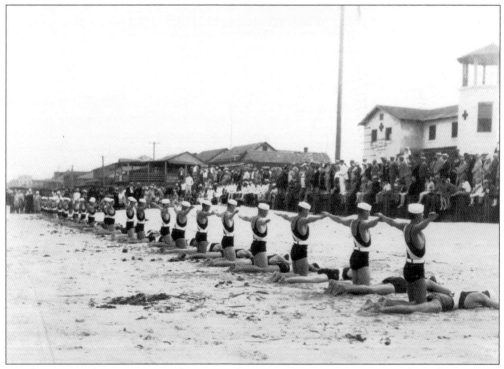

Beachgoers watch American Red Cross Volunteer Life Saving Corps members demonstrate lifesaving techniques in 1926. The crowd is standing in front of the corps' second station, which had been built in 1920.

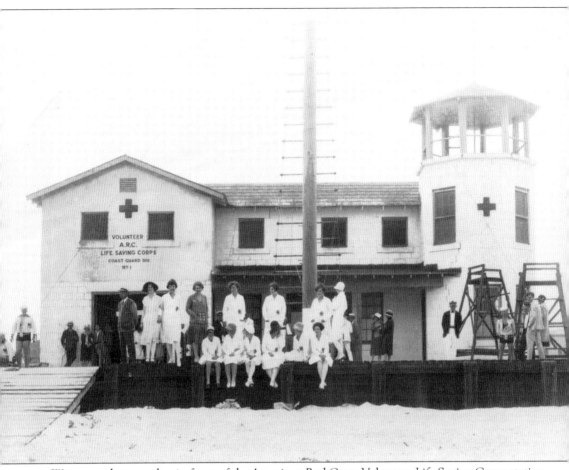

Women and men gather in front of the American Red Cross Volunteer Life Saving Corps station in 1926 in Jacksonville Beach. The station was built in 1920 to replace a smaller station at the same location. The station pictured here was torn down in the late 1940s and replaced by a larger and more modern building, which still stands.

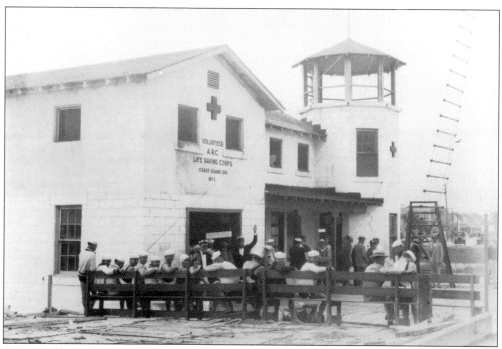

A group of lifeguards gathers outside the American Red Cross Volunteer Life Saving Corps Station in 1926. "The appearance of the guards on the beach every summer 'inspires' bathers," a newspaper story at the time reported.

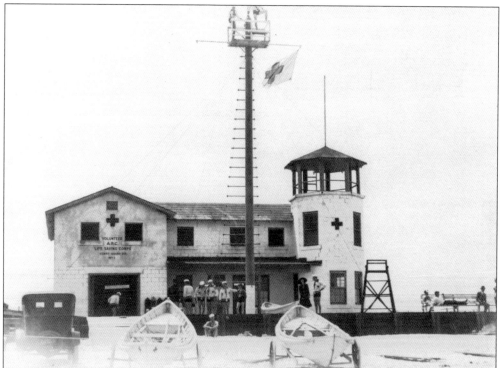

This 1926 photograph shows the rescue boats used by the lifeguards in Jacksonville Beach.

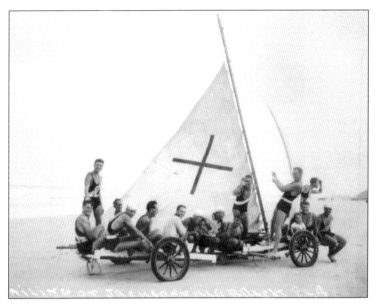

Jacksonville Beach lifeguards cruise the beach in a "San Sailor" beach sailboat on April 1, 1929. This photograph appeared in the *Jacksonville Beach News*, a community newspaper.

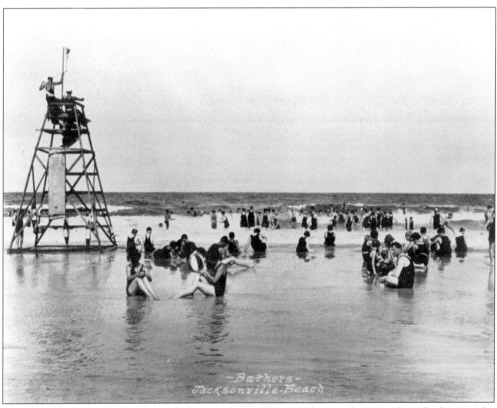

American Red Cross Volunteer Life Saving Corps lifeguards keep a close watch on bathers in the ocean at Jacksonville Beach during the summer of 1929.

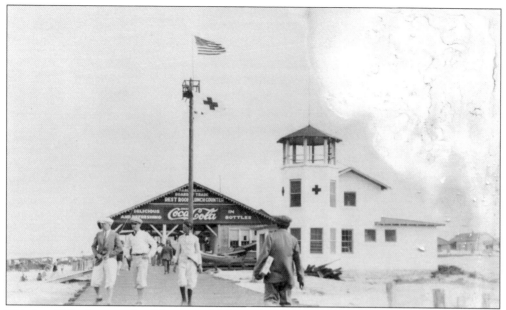

This is a 1931 photograph of the second lifeguard station in Jacksonville Beach, which was built in 1920. It was located next to a pavilion, and the tall tower in front gave lifeguards an aerial view of the beach. They had to climb a narrow ladder to get up to the top.

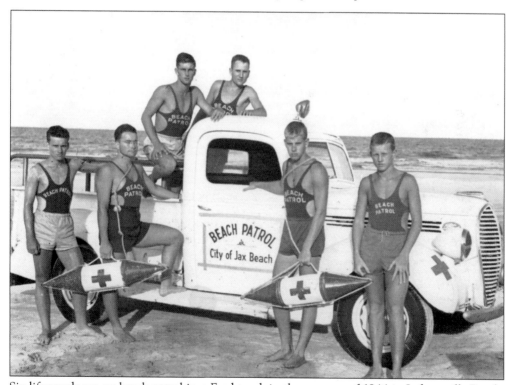

Six lifeguards are on beach patrol in a Ford truck in the summer of 1944 in Jacksonville Beach. They are, from left to right, Paul "Pablo" Smith, Richard "Dick" Griffin, Harold "Andy" Anderson, Atwood Stokes, Hulet Phillips, and Leslie Poe.

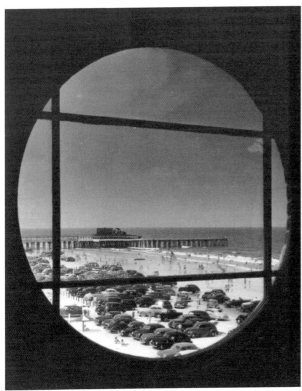

The coastline of Jacksonville Beach is framed through the window of the American Red Cross Volunteer Life Saving Corps Station. The year is not identified, but the photograph was taken after 1948, which was when the present station was completed.

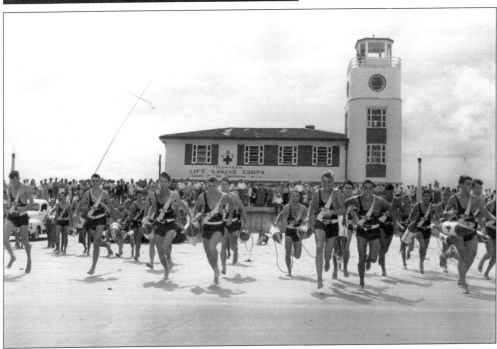

Pictured during the summer of 1948, American Red Cross Volunteer Life Saving Corps lifeguards run into the ocean at the beginning of their annual marathon at Jacksonville Beach. Some of the lifeguards are identified as George Ashley, Herbert Oatman, Don McLane, and Jay Ray Brown.

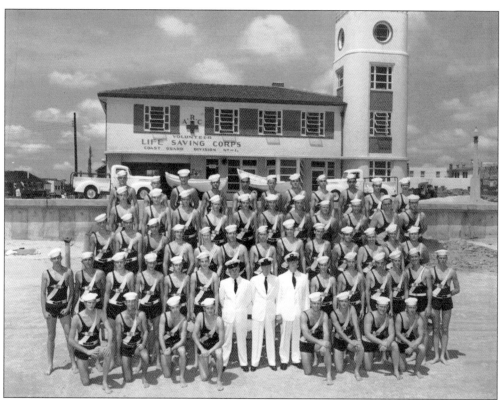

The American Red Cross Volunteer Life Saving Corps poses in front of the station in Jacksonville Beach in 1949. The station was new, and the corps had many members that year. During World War II, their numbers were much smaller. The officers are posing in their dress uniforms.

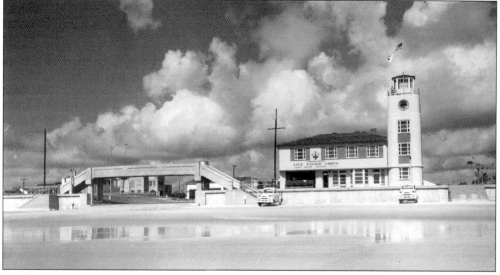

A pedestrian walkway over the entrance to the beach on Beach Boulevard allowed people to avoid traffic, as depicted in this 1960 photograph. Cars were still permitted to drive onto the beach at the time, and the walkway was next to the American Red Cross Volunteer Life Saving Corps Station. That walkway was dismantled around 1980 after beach driving was banned.

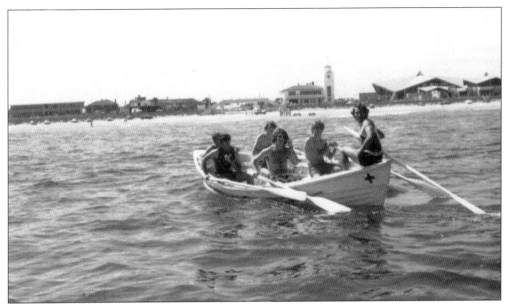

Five American Red Cross Volunteer Life Saving Corps lifeguards man the oars of a boat offshore at Jacksonville Beach in April 1971. The station at the foot of Beach Boulevard and the city's Flag Pavilion can be seen in the background.

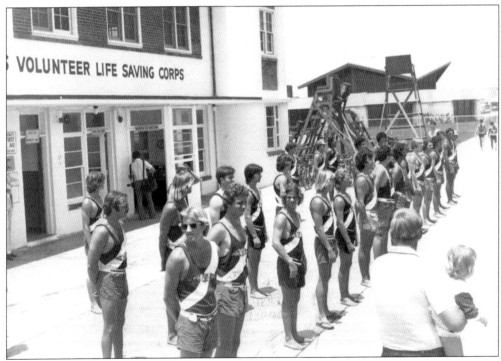

American Red Cross Volunteer Life Saving Corps lifeguards line up for review in the spring of 1977 at the annual Opening Day at the Beaches celebration, which kicks off the summer season. The name of the first official day of the summer season changed over the years, but the lifeguards have always been a part of the festivities.

Three

RESIDENTS AND VISITORS

Even though they lived in primitive conditions, early settlers of Jacksonville Beach held the town in high regard. Some served as community leaders, and others were influential business people.

The seaside community also attracted a wide variety of interesting visitors drawn by the beaches as well as the business and recreational possibilities. Fortunately, whether they lived there or were just passing through, many people documented their adventures with photographs.

Gen. Francis E. Spinner, who bought one of the first lots for sale by the railroad, invited friends and family to join him at his large tent-home, Camp Josephine, which overlooked the ocean. He also enjoyed the delights of nearby Murray Hall Hotel, as indicated in an ode he wrote to his beloved "Pablo by the Sea." "Oh that's the place for me, at dear Pablo by the Sea," he wrote. "All should know that sea bathing is the key to where healthful blessings flow . . . now a ball at Murray Hall, there's joy and revelry."

In 1905, Jacksonville businesswoman Cora Crane built Palmetto Lodge between Eighth Avenue and Ninth Avenue North and ran it as a bordello.

When H.M. Shockley became mayor in 1907, the town charter issued an ordinance prohibiting the wearing of indecent bathing suits. The idea of what constituted an indecent bathing suit changed through the years, however, and later on many young women enjoyed competing in bathing beauty contests and taking part in annual beach parades.

An influential member of the African American community was Rhoda L. Martin, a former slave and very early resident of Pablo Beach who lived to be 116 years old. She helped found a school and church for African Americans.

In 1922, visiting Army lieutenant James Doolittle flew from Pablo Beach to San Diego, breaking the transcontinental speed record in a de Havilland DH-4 biplane. Crowds gathered on the beach to watch his take-off.

Developer B.B. McCormick came to Pablo Beach in 1918 to help build it. His family-owned contracting business built roads and buildings and other structures over a period of several decades. His son J.T. served as mayor of Jacksonville Beach, and J.T.'s wife, Jean Haden McCormick, helped found the Beaches Area Historical Society.

Photographer Virgil Deane set up a photography business in Jacksonville Beach in the 1940s and took pictures all around town for several decades. Thousands of his images went to the historical society after his death. Thanks to Deane and many other amateur and professional photographers, many of Jacksonville Beach's residents and visitors live on in photographs.

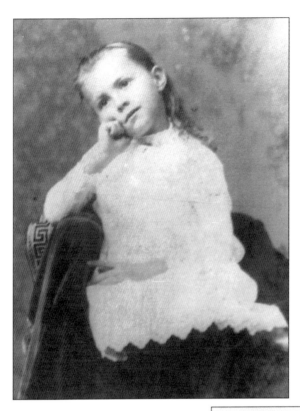

Ruby Scull poses for a portrait in 1885, a year after her parents, William and Eleanor Scull, named a beach town after her in northeast Florida in 1884. The name of the town was changed to Pablo Beach the next year and then to Jacksonville Beach in 1925.

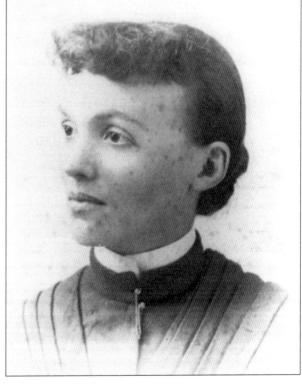

Eleanor Scull poses for a portrait in May 1891. She and her husband, William, were the first official residents of the town that would become Jacksonville Beach, and she was the town's first postmaster. The Sculls lived in a tent when they first moved to the beach, as did many of the first pioneer families.

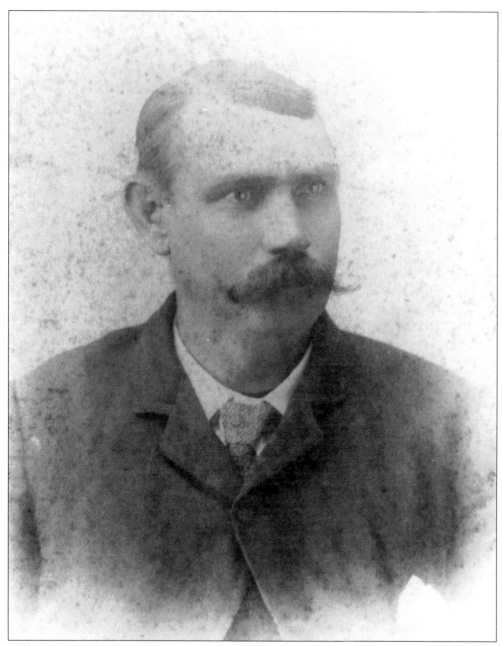

William Scull poses for a portrait in 1891. He and his wife, Eleanor, were the first official residents of the town that would become Jacksonville Beach. William worked for the railroad that connected Jacksonville to Pablo Beach.

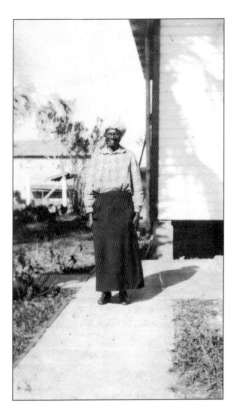

A former slave, Rhoda L. Martin was an early black resident of Pablo Beach. Shown around the time the town was founded, this photograph was taken in an area where African Americans settled called The Hill. A beloved and respected community leader, Martin helped start a school for African American children and a church. She lived to be 116 years old.

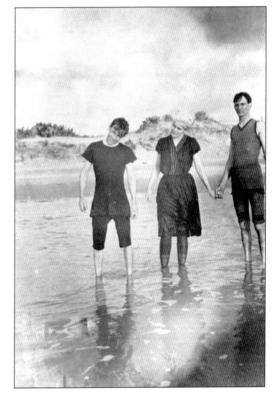

Albert Seegar and Ethel Seegar, holding hands, are seen with an unidentified man around 1900 in Pablo Beach. The trio was likely visiting to the still-mostly undeveloped town. Note the wild sand dunes in the background.

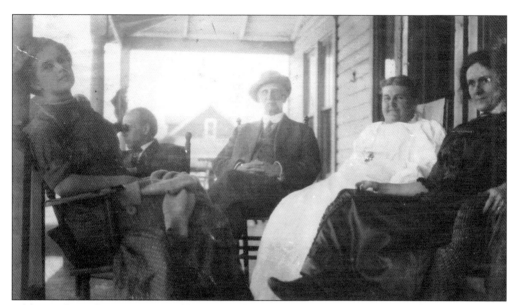

Pablo Beach residents Anna Purcel (far left) and Mary Perkins (second from the right) socialize in the early 1900s. Purcel was a longtime resident of the town, and Perkins ran a bathhouse and lodge.

Longtime resident Anna Purcel (right) poses on a buoy with an unidentified friend in the early 1900s in Pablo Beach.

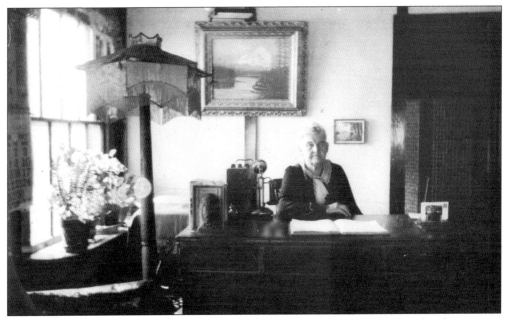

Mary Perkins is seen at work in her office at the Perkins Bathhouse in Pablo Beach. The year was not recorded, but her business was one of the earliest to be established in the town.

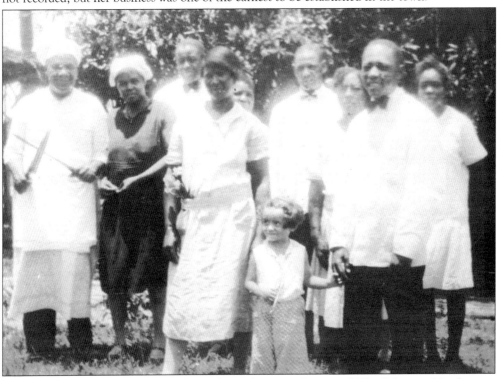

Employees of Palmetto Lodge, which was located at First Street and Third Avenue North, pose for a group picture in 1930. Palmetto Lodge became a popular place for tourists to stay after Mrs. Crane died in 1910, and it was bought by the Haden family. Those identified are Chef Will Cook, Lula (in white dress), and little Gweneth Munketrick holding Sylvester's hand.

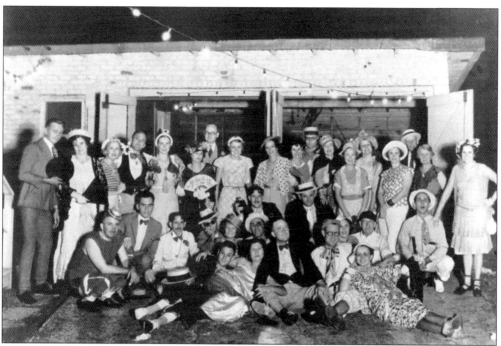

A crowd of Jacksonville Beach residents has fun at a "tacky" costume party at Claud North's house in 1933. It depicts classic fun at the beach.

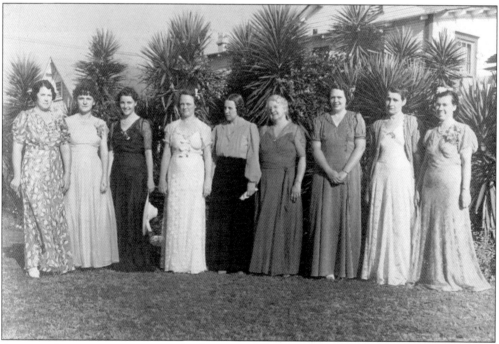

A group of women participates in the first annual flower show of the Jacksonville Beach Garden Circle in November 1936. They are, from left to right, Mrs. Martin G. Williams, Mrs. Lewis Hester, Mrs. Jean Haden McCormick, Mrs. Sue Dale Shine, Mrs. Turner Knight, Mrs. Bernice W. Haden, Mrs. Harry B. Williams, Mrs. Sue Smith, and Mrs. Elizabeth Hore.

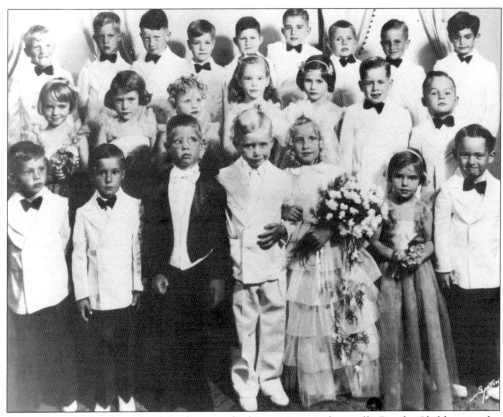

Lonita Foster's dancing school is photographed in 1937 in Jacksonville Beach. Children in the image include Ann Blackwell, Anita Regor, Suvan Shine, Earlene Roberts, Marian Mills, Marion Marvin, Bobby Wolverton, Weston, Minton, Billy Helvenston, Buck Brunson, Billy Regor, Roger Porter, and Colson Mills.

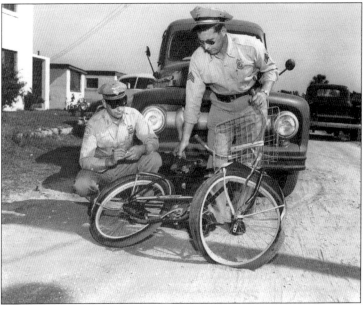

Jacksonville Beach police officers investigate a wrecked bicycle in the mid-20th century, probably in the late 1940s.

A group of people is pictured with Lillian Weimer (third from right) in 1944 at Jacksonville Beach. They are probably in front of Weimers Lodge, which was located at 509 First Street South. Weimers Lodge was another popular place for tourists to stay.

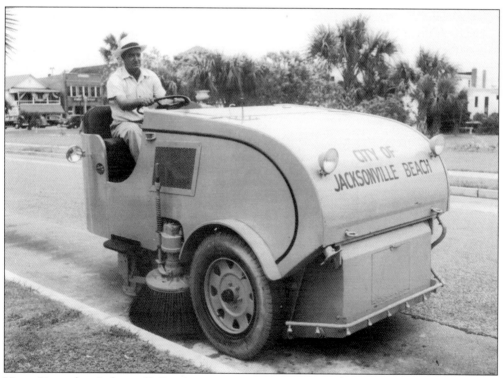

Harry Sistrunk, a Jacksonville Beach street sweeper, is seen at work on First Street in June 1947.

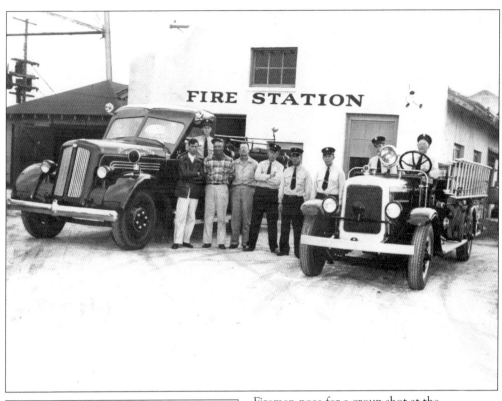

Firemen pose for a group shot at the Jacksonville Beach Fire Station around 1950. They are, from left to right, Ralph Jones, Philip Klein, Harry Sistrunk, Ben Adams, Howard Mickler, Buck Brunson, Jack Bush, Bud Reed, and King Haddock.

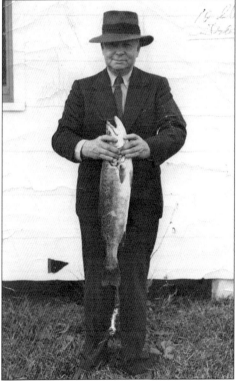

Longtime Jacksonville Beach resident and community leader A.G. Penman loved to fish and often posed for photographs with his catch of the day. Here, he is wearing a suit, hat, and tie holding a 10-pound sea trout. The year was not recorded.

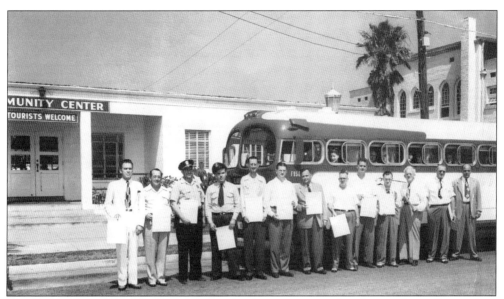

Community leaders prepare for an inaugural sightseeing trip via bus from Jacksonville Beach to St. Augustine and Marineland in the mid-20th century. They are, from left to right, Mayor I.D. Sams; Charlie Weaver, a member of the Jacksonville Beach Police Department; bus driver H.M. Shelley, secretary of the chamber of commerce; Councilman Jerry Kirkman; Martin G. Williams, president of the chamber; City Manager Hugh MacCotter; C.E. Young; Councilman Dr. G.A. Cotton; Councilman W.E. Montgomery; Councilman Jack Marvin; and three unidentified men.

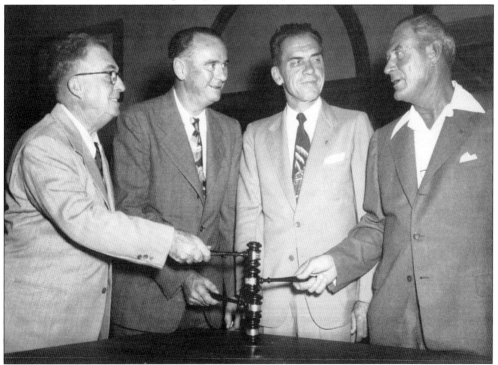

Four mayors of Jacksonville Beach pose for a group shot in the mid-20th century. They are, from left to right, Martin G. Williams, H.A. Prather, I.D. Sams, and W.E. Montgomery.

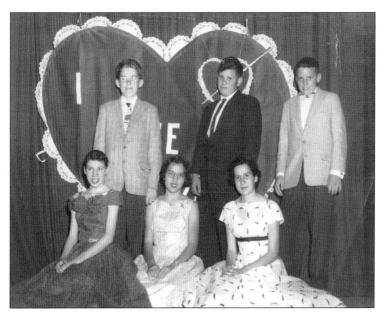

Eighth-grade students attend a Fletcher Junior High cotillion in the mid-20th century. The unidentified students look like they are having a good time.

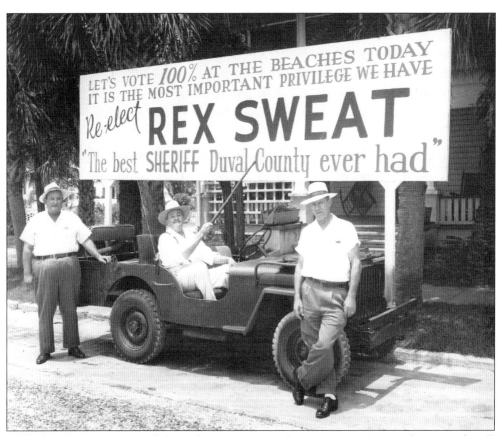

Ed (left) and B.B. McCormick (center) campaign to reelect Rex Sweat for Duval County sheriff. B.B. McCormick was a major developer of Jacksonville Beach.

J.T. McCormick (left) and Tommy Thomas, mayor of Valdosta, Georgia, are photographed together at the Jacksonville Beach Band Shell in Prather Park in 1956. McCormick was the son of developer B.B. McCormick and served as mayor of Jacksonville Beach.

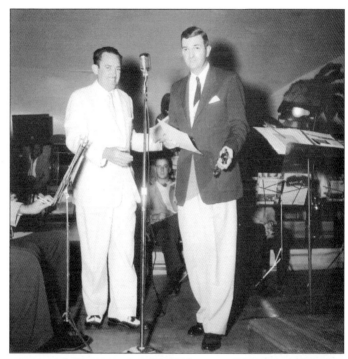

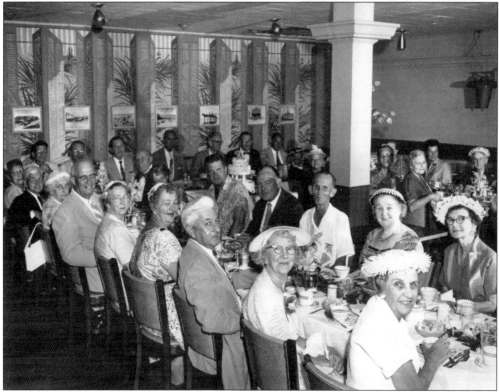

Jacksonville Beach residents celebrate the 50th anniversary of the incorporation of Pablo Beach on May 27, 1957, at Bill's Restaurant.

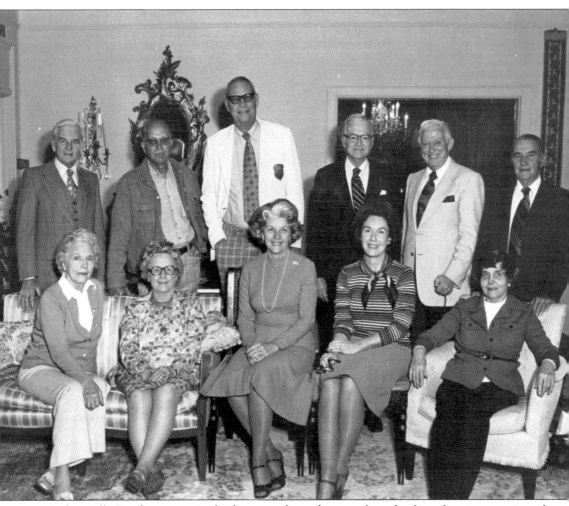

Jacksonville Beach community leaders pose for a photograph at the first planning meeting of the Beaches Area Historical Society on February 22, 1978. They all believed it was important to preserve the town's history, and their efforts eventually led to the creation of the Beaches Museum & History Park, where thousands of archives and important community records are stored. They are, from left to right, (sitting) Lois Roberts, Edythe Chambers, Jean McCormick, Beryl Dryden, and Dorothy Doggett; (standing) Ish Brant, Ed Shore, Bill Dryden, Charlie Howell, Virgil Deane, and Frank Doggett.

Four

SCHOOLS

The few children who lived in Pablo Beach year-round in the early 1900s attended Pablo Beach School. Photographs from 1906 show it was a one-story wooden building located on Palmetto Avenue in the heart of town. Other early photographs indicate it served young students and teenagers.

By 1924, the town needed a larger building, and a modern two-story schoolhouse was built. Construction began in the spring, and an April 1924 article in the *Pablo Beach News* records how excited the community was to get a new school. "The new Pablo Schoolhouse," costing $65,000, is "among the finest in the country," it stated. The brick-and-tile building and its playground "will occupy the entire block of four acres on the east of First Street, west on Second Street, north on Shockley Avenue, and south on Griffith Avenue."

The school opened in late 1924 and served children in elementary grades for several decades. After it was torn down, the senior citizen apartment building of Pablo Towers was constructed in that location, where some of the street names have since been changed.

High school students from all the beach towns had to travel into Jacksonville to attend high school until Fletcher High was built in Jacksonville Beach. Construction began in 1937 on the west side of Third Street, and the school was named for Florida's US senator Duncan Upshaw Fletcher. Young student Jean Haden, later the wife of Jacksonville Beach mayor J.T. McCormick, helped select the school's colors of purple and white. From the beginning, Fletcher was the pride of the beaches and still is a community school well supported by residents of all ages, many of whom are alumni.

African American children attended separate schools until desegregation in the late 1960s. The first school serving black residents was founded by Rhoda L. Martin, a community leader who was a former slave. She started the first school in her home, and elementary students later attended the Jacksonville Beach School for Colored Children No. 144. The Rhoda L. Martin Cultural Heritage Center is now located in that building.

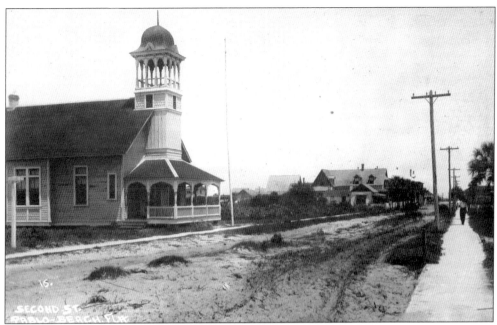

The original Pablo Beach School is pictured in the early 1900s. The photograph shows how undeveloped the town of Pablo Beach was at that point in time.

Graduating from Pablo Beach School, eighth graders pose for a group photograph in 1921. They are, from left to right, Mary Shad, Marion Jeffers, Richard Ivory, Edward Wright McCormick, Mrs. Charles Williams (teacher), Erie Smith, and Alma Louise "Happy" Gonzales.

This is a class photograph from Jacksonville Beach School No. 50 in 1927. Those identified are Paul Stordies (front row, second from left), Babe Miller (front row, fourth from left), Hazel Seaver (front row, fourth from right), and Neal Crowe (front row, second from right).

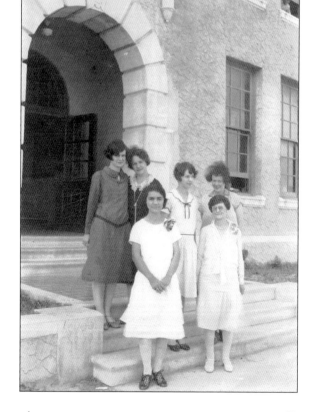

This is the faculty of Jacksonville Beach Elementary School No. 50 during the 1927–1928 school year. They are, from left to right, (first row) Myrtle Hood and Ella Anders; (second row) Gladys Matthews (Armstrong), Florence Akard (McNelty), Kate Coley, and Margaret Williams (Mrs. Bert Reid).

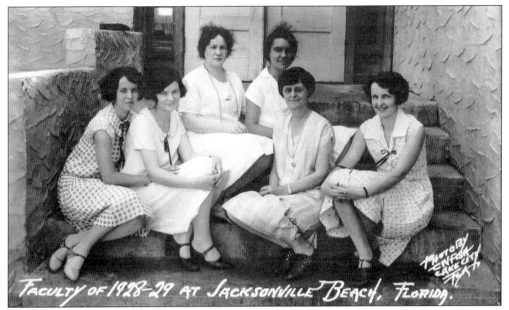

This is a photograph of the faculty of 1928–1929 at Jacksonville Beach Elementary School No. 50. They are, from left to right, Margaret Miller, Gladys Mathews, Florence Akard, Myrtle Hood, Ella M. Anders, and Miss Giles. The school opened in 1924 as the Pablo Beach School, but the name was changed after the name of the town was changed. It became School No. 50 under the Duval County School District.

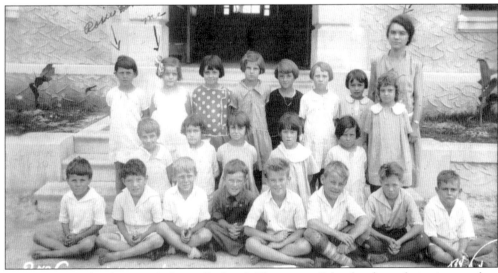

It was tradition for classes at Jacksonville Beach Elementary School to have their picture taken every year. This photograph of the second-grade class was taken in 1929. They are, from left to right, (first row) John Bell, Moses Stormes, John Barnard, William Ackland, Herbert Nelson, Albert Johnson, Alder Starng, and Gerald Iwanoskie; (second row) Corrine Sistrum, Eula Mae Griner, Ins Strickland, Doris Strang, and Miriam Treadwell; (third row) Roxie Horn, Jean Haden, Katherine Wright, Alberta Kelly, Ruth Larsen, Marguerite Petty, Jane Williams, and Virginia Lee Wainright; the teacher is Myrtle Hood.

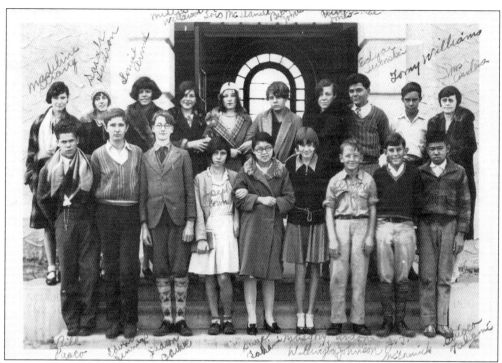

This is a class of Jacksonville Beach Elementary School No. 50 students in 1930. Pictured are, from left to right, (first row) Bill Pasco, Edwin Jennings, ? Barker, Isabel Stormes, Suye Takami, Rosemary Wellington, Antone Johnson, J.T. McCormick, and Shigeo Takami; (second row) Madeline Strang, Sarah Hudson, Louise Arnau, Millie Wilkerson, Lois Mc Daniel, Betty Jones, Daisy Mae Imes, Edgar ?, Tony Williams, and Ella Anders.

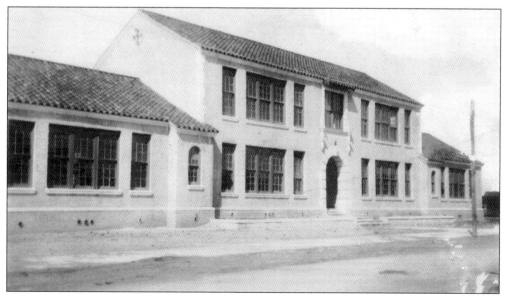

This is an exterior view of Jacksonville Beach School No. 50 in 1931. Modern and spacious, "It is among the finest in the country," a local paper proclaimed when the school opened in 1924.

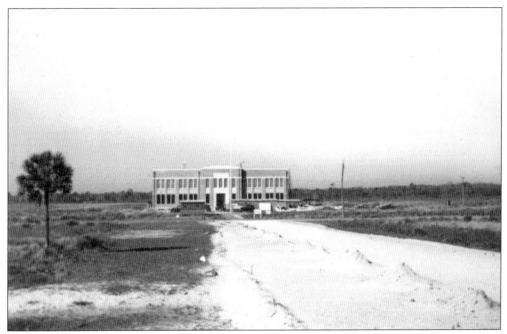

Fletcher High School is under construction in March 1937. Frank Mitchell was the owner of the contracting firm that built it. This photograph shows that the land around the school on Third Street was undeveloped at the time. Decades later, a new larger Fletcher High School was built a few blocks away, and the original high school was converted into a middle school.

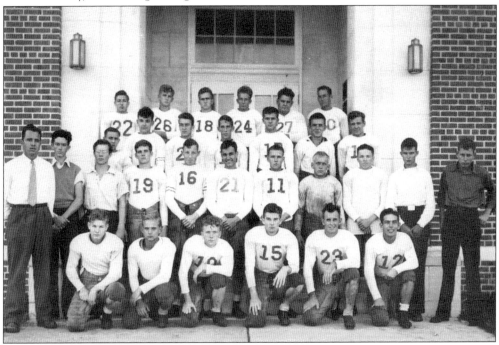

The Fletcher High School football team is pictured in 1938. It was the first team of the new Jacksonville Beach school, which had recently opened to serve high school students in the Jacksonville Beaches communities.

Fletcher High School football player C. Doerr is pictured here in his uniform in 1939. He was one of the school's first players. The brand-new school is behind him.

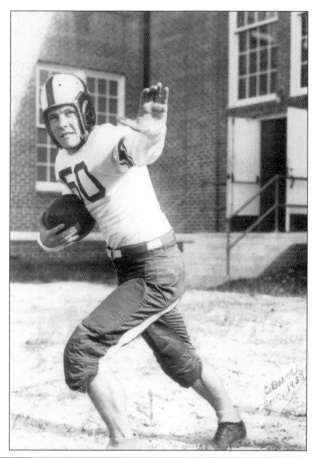

This is the first grade class at Jacksonville Beach School in 1940.

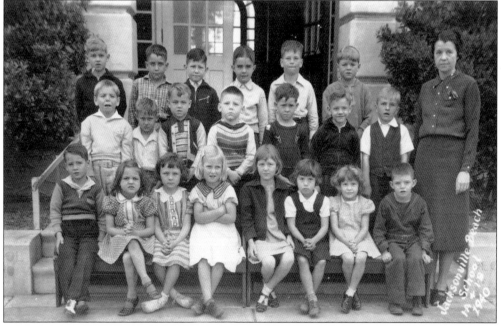

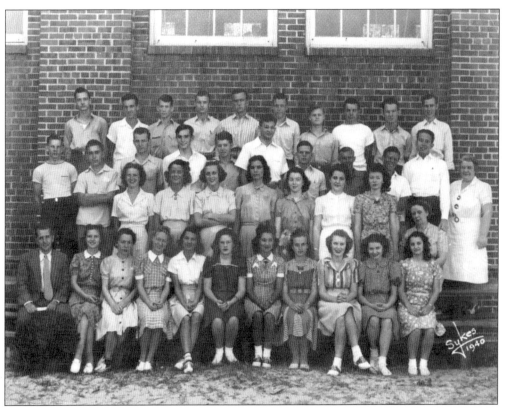

Fletcher High School's graduating class of 1940 poses with principal Frank Doggett.

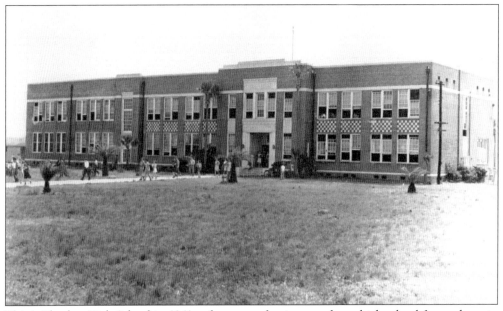

This is Fletcher High School in 1941, a few years after it opened as a high school for students in Jacksonville Beach and other beach towns. Before it opened, students had to go into Jacksonville to attend high school.

The faculty of Jacksonville Beach School No. 50 poses with principal Dwight Wilson in the 1940s.

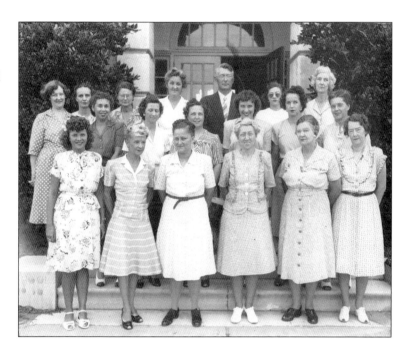

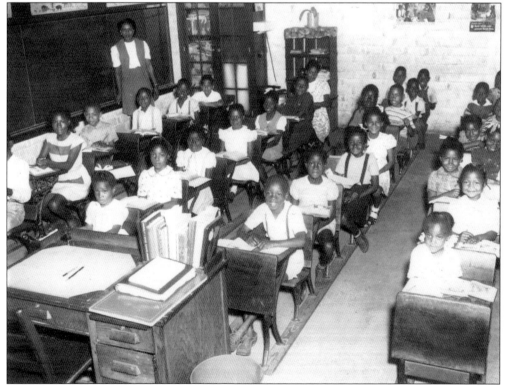

Orpah Jackson's class at the Jacksonville Beach School for Colored Children No. 144 is pictured in 1947. The photograph shows what a typical classroom looked like.

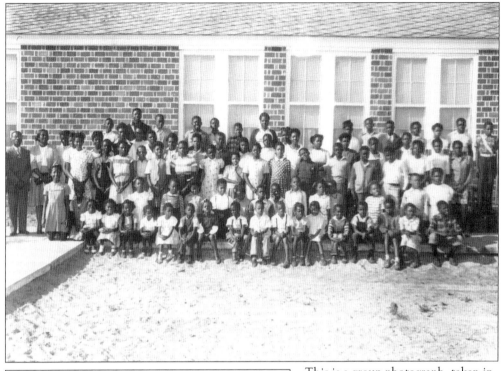

This is a group photograph, taken in 1947, at Jacksonville Beach School for Colored Children No. 144.

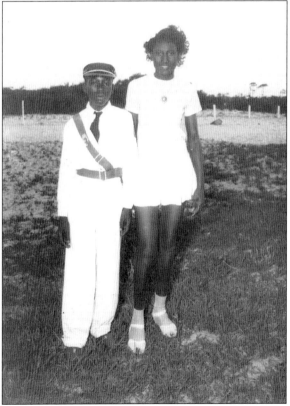

Two students from Jacksonville Beach School for Colored Children No. 144 are pictured in 1949. They are Robert Brooks, captain of the boy patrol, and Ruby McGhee.

Elizabeth Ivy is the May queen for 1949 at Jacksonville Beach School for Colored Children No. 144. The school was located at 315 South Tenth Street.

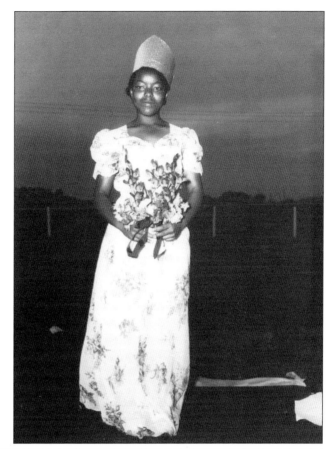

Drill team students practice at the Church of God at Third Avenue and Tenth Street South in 1949. The two who can be identified in this photograph are Elsie Jackson (front left) and Ruby Lee McGhee (front right).

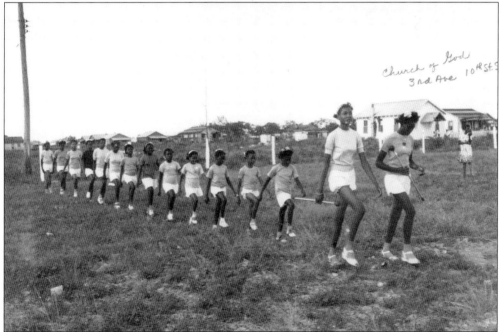

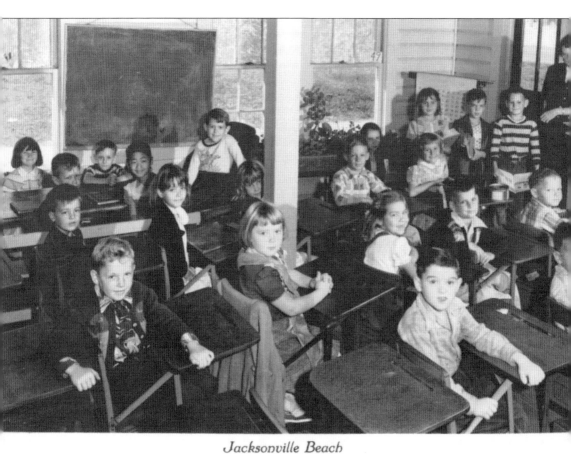

Jacksonville Beach
Elementary School

Miss Lee
Teacher

1st. Grade 1951-52

Dwight L Wilson
Principal

Miss Lee's 1951–1952 first-grade class at Jacksonville Beach Elementary School poses for a group photograph. Dwight Wilson was principal at the time. This photograph shows a typical 1950s classroom.

Five

STORMS

Over the years, Storms have had a major impact on Jacksonville Beach, which is in a vulnerable location on the northeast coast of Florida.

From the time the town was founded, people have photographed damage done to buildings, piers, and the boardwalk from major weather events. Severe storms that came in from the sea flattened buildings into rubble, twisted roller coasters, and destroyed beloved businesses and homes.

The most photographed storm is Hurricane Dora, which blew ashore in the fall of 1964. It made landfall shortly after midnight on September 10 in Vilano Beach, about 30 miles south of Jacksonville Beach, with sustained winds between 115 and 125 miles per hour. It was the first recorded tropical cyclone to make landfall in the region and damaged many buildings in Jacksonville Beach. The Jacksonville Beach Pier was destroyed by the hurricane-force winds, and bulkheads were smashed. Many homes were swept to sea. Rainfall was heavy, and residents lost power for many days. Buildings and the boardwalk area were rebuilt, as was a new pier, but the storm caused millions of dollars worth of damage.

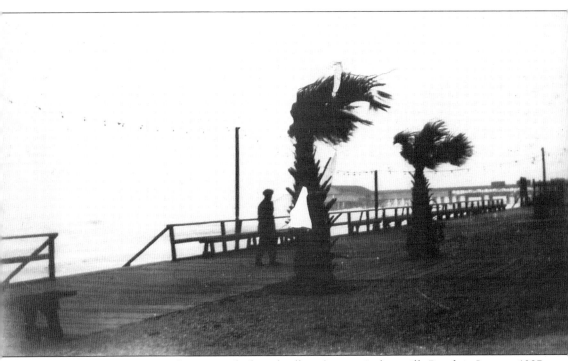

An ocean storm comes ashore onto the boardwalk and pier in Jacksonville Beach in January 1927. Many storms have damaged structures through the years in the northeast Florida beach town. Sometimes, they were rebuilt, but at times people decided it was not worth it.

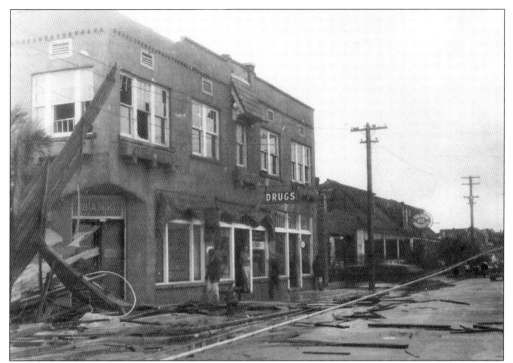

A hurricane in 1928 damages the Beach Bank in Jacksonville Beach, as well as a drugstore (far right) and Standard Oil Products office. This image is of the area around First Street and First Avenue North.

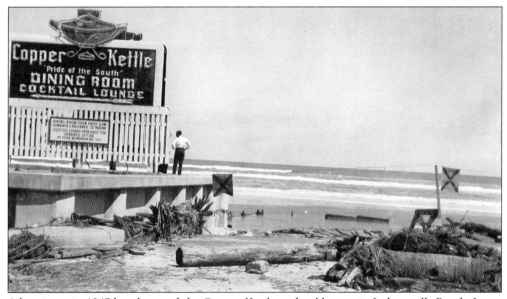

A hurricane in 1947 has damaged the Copper Kettle cocktail lounge in Jacksonville Beach. It was located at Fifteenth Avenue North near the ocean.

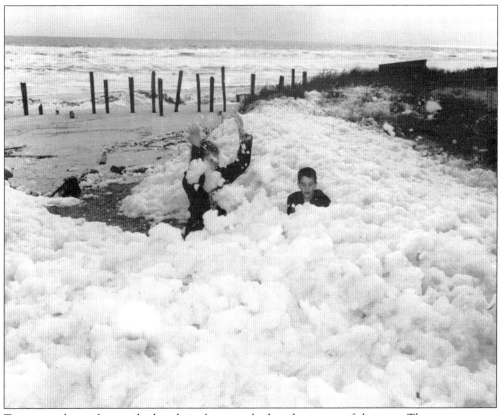

Two young boys play on the beach in foam washed up by a powerful storm. The year was not documented, but it appears to be mid-20th century.

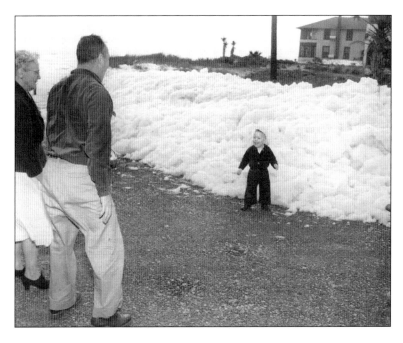

Adults watch a young boy play in mountains of foam that washed up on a beach in Jacksonville Beach.

A small boy in winter cap and coat stands in an "ice cave" of ice-coated leaves in Jacksonville Beach after a winter storm. He is sucking on an icicle and standing in heavily ice-coated grass. This type of weather is unusual for the Florida town.

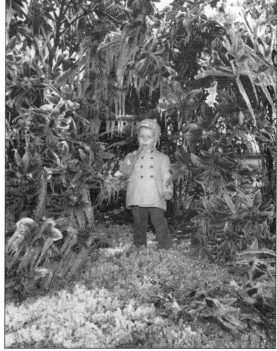

After a winter storm, a child in cap and jacket sits on a swing that is covered with ice. Long icicles hang from the teeter-totter, and the grass is covered in ice chunks—an unusual sight in Jacksonville Beach.

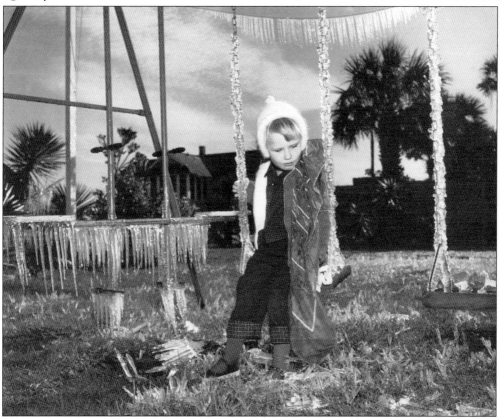

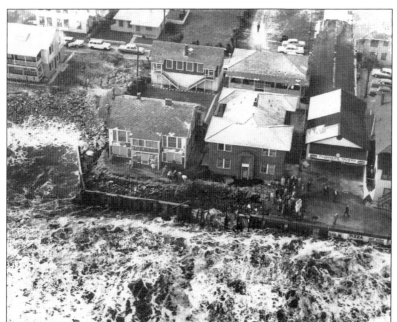

This is an aerial view of damage done to the shoreline of Jacksonville Beach from a storm in the mid-20th century.

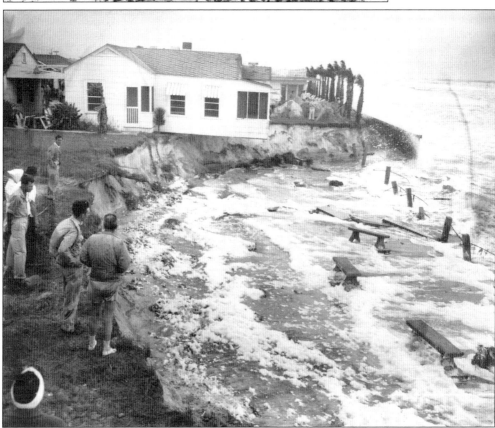

A photograph shows damage done to the shoreline of Jacksonville Beach during a storm in the mid-20th century.

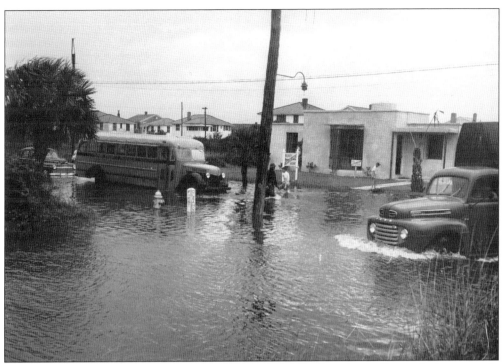

Here, a storm in the mid-20th century causes major flooding in Jacksonville Beach. Some people can be seen examining the damage.

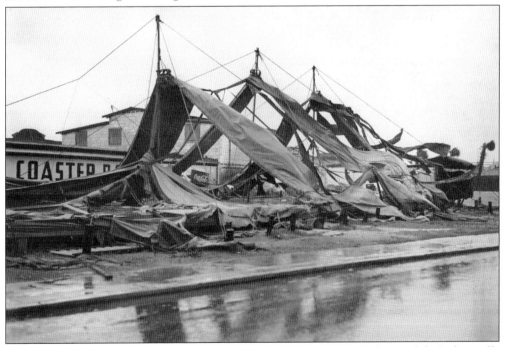

High winds from a powerful storm that came in from the ocean in 1963 damaged the Jacksonville Beach Skating Rink, located on First Avenue North, one block off oceanfront. The canvas was ripped to shreds.

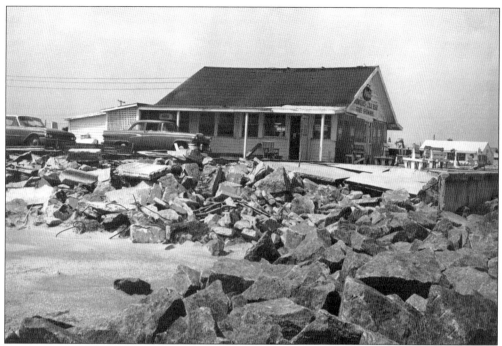

Hurricane Dora, which made landfall in September 1964, has impacted Mac's Shack, located at Seventeenth Avenue South. It was owned by Lynda McLean and sustained some damage to the roofing and undercut concrete slabs in the parking area. Extensive rubble can be seen in foreground.

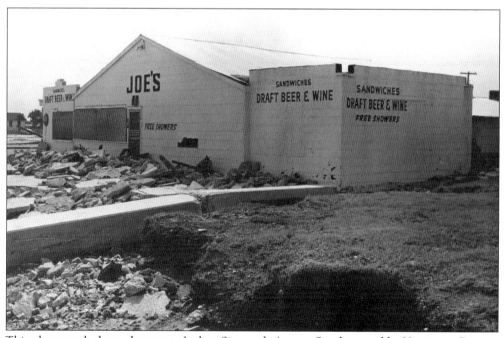

This photograph shows damage to Joe's at Sixteenth Avenue South caused by Hurricane Dora in September 1964. The damage done by the storm to buildings and structures was well documented in photographs.

This photograph shows the impact of Hurricane Dora to some Jacksonville Beach houses. Many homes were destroyed.

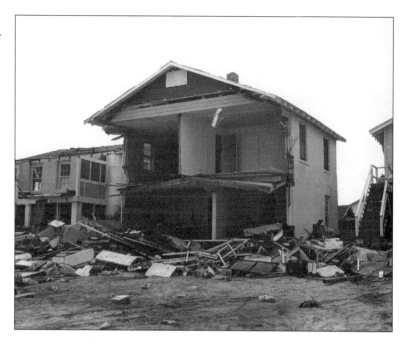

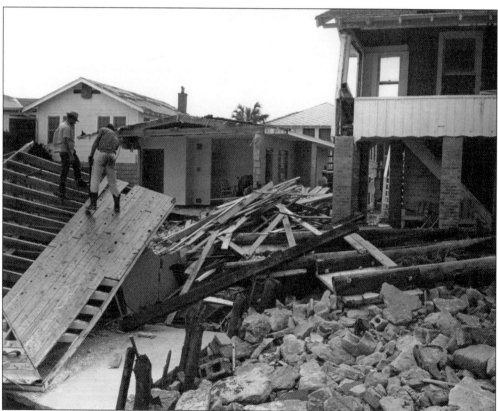

A two-story house in Jacksonville Beach is essentially rubble after Hurricane Dora. This image shows planking and joists, piles of boards, timbers, pilings, and damage to the upper story and roof.

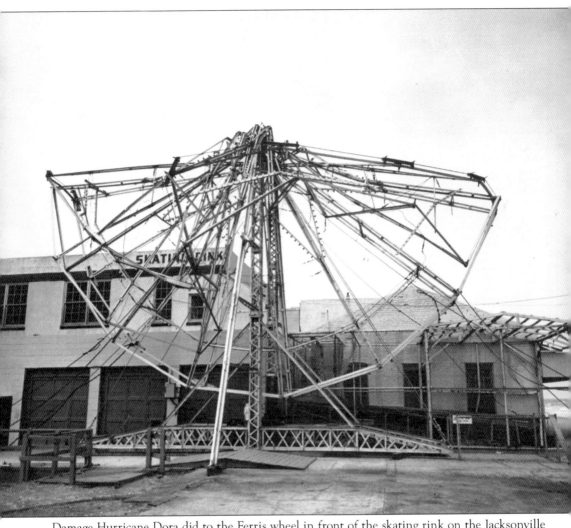

Damage Hurricane Dora did to the Ferris wheel in front of the skating rink on the Jacksonville Beach boardwalk is visible here.

Six

BOARDWALK AND PIERS

For many years, the boardwalk in Jacksonville Beach was the heart of the town. Photographs show that the first boardwalk was narrow and constructed of planks laid along the dunes. In 1915, businessman Martin Williams built a wide boardwalk with many attractions, including a dancing pavilion, shooting galleries, boxing and wrestling rings, restaurants, bathhouses, and shops. People of all ages strolled up and down the wooden promenade, socializing and breathing in the refreshing salt air.

The town also had an oceanfront amusement pavilion, called "Little Coney Island," that included pool tables and a bowling alley. The weekly newspaper, the *Pablo Beach News*, even published the names of each week's best bowlers and their scores.

Trotter's Dance Pavilion was a very popular spot on the boardwalk and was known as the finest and largest dance floor in the South in 1922. It also claimed to have the best music to be found at any dance hall, and advertisements in the *Pablo Beach News* urged people to "follow the crowd to Trotter's" and to tell friends to "meet you at Trotter's."

Shad's Pier, a wide fishing and dancing pier, opened in 1922, thrilling residents and visitors alike. It extended out over the ocean for over 600 feet; it was 25 feet wide for the first 450 feet and widened to 100 feet for the balance of 150 feet to encompass the dancing pavilion. The owner of Trotter's was soon managing the dancing hall on Shad's Pier, and dance marathons were all the rage in the city. In a May 1922 article in the *Pablo Beach News*, readers learned that the new Shad Bathhouses for men and woman were "modern in every respect, roomy and large with ample dressing rooms" and that "the bathhouses have 550 rooms, arranged in rows that extend from the Boardwalk to First Street."

Little Coney Island was condemned in January 1924 due to the lack of needed repairs and was torn down, but the boardwalk continued to flourish. In 1927, a 93-foot-high roller coaster was built, which remained a beach landmark until it was taken down in 1950.

Jacksonville Beach also had other fishing piers. One opened in 1960 at Sixth Avenue South and was very popular until it was destroyed by Hurricane Floyd in 1999.

Shad's Pier burned in 1937, was rebuilt, and then later destroyed again by fire in 1961. The town's current fishing pier opened in 2004 at Fourth Avenue North.

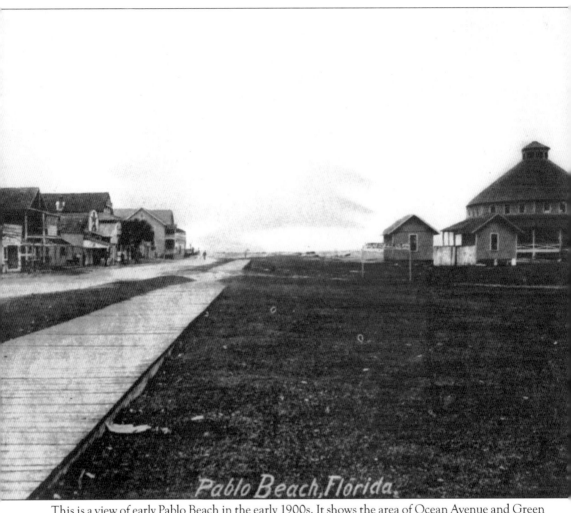

Pablo Beach, Florida.

This is a view of early Pablo Beach in the early 1900s. It shows the area of Ocean Avenue and Green Street. The popular amusement pavilion Little Coney Island is on the right. It offered dancing, skating, swimming, and bowling. Many streets in this area were later renamed.

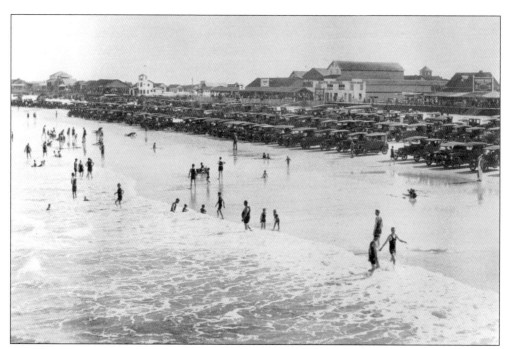

Crowds of people swim in the ocean in Pablo Beach in the 1920s. It must have been a summer weekend because of all the cars parked on the beach in front of the boardwalk.

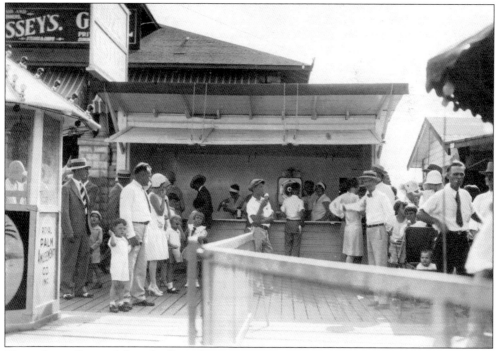

The Jacksonville Beach boardwalk in the summer of 1925 was a bustling place. This photograph shows Bussey's Grill to the left. There is also a frozen custard stand, owned by Jessie L. and Kathryn Sullivan. Kathryn is on the left behind the counter. Perry Humphrey and Jessie Sullivan Humphrey are on the right behind the counter.

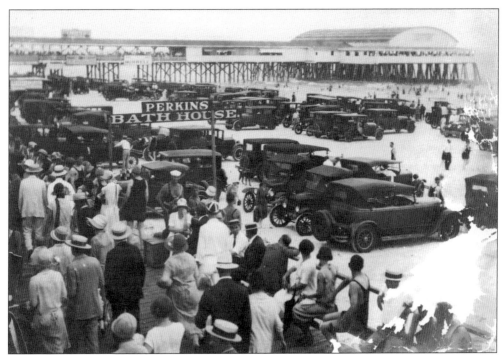

Seen is part of the Jacksonville Beach boardwalk in 1927. Ocean Driveway, the pier, and a sign for Perkins Bathhouse are in the foreground. The photograph appeared in the *Jacksonville Beach News* on May 23, 1927.

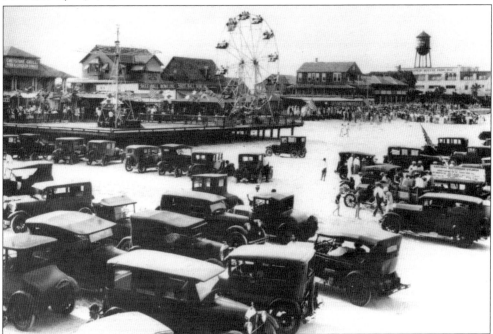

This wide-angle photograph shows what the beach at Jacksonville Beach looked like on a crowded summer day in 1928. It shows the boardwalk and Ferris wheel, cars on the beach, and many other structures.

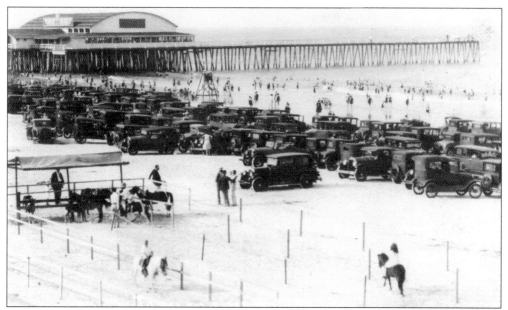

Here is the Jacksonville Beach boardwalk in 1929; note that people could pay for a pony ride on the beach at this time.

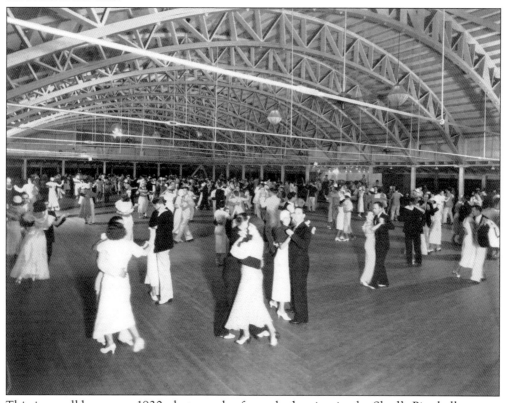

This is a well-known c. 1930 photograph of people dancing in the Shad's Pier ballroom at Jacksonville Beach. The pier jutted out over the ocean from the boardwalk between Second and Third Avenue North.

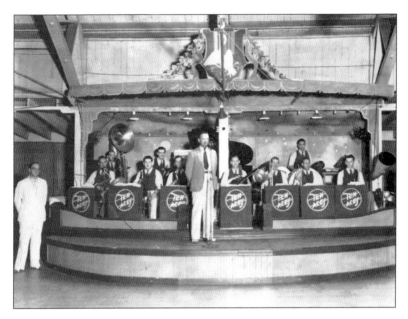

This 1930 photograph shows the inside of the dance pavilion on the Jacksonville Beach pier. The band Ten Aces is seen with the announcer. Grady "Pop" Trimble, the manager of the pier, is on the far left.

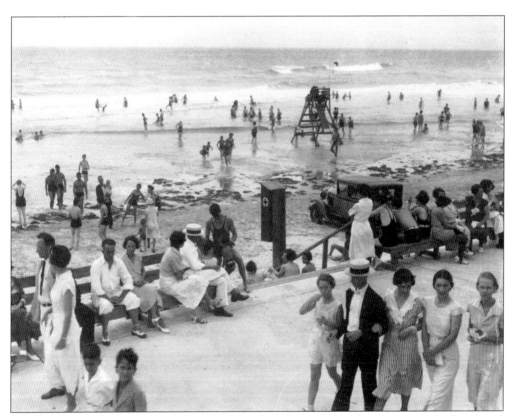

Pictured is the Jacksonville Beach boardwalk in the 1930s with people relaxing on the beach and swimming in the ocean beyond. Lifeguards are monitoring the swimmers.

A woman works at a custard stand on the Jacksonville Beach boardwalk in the 1930s.

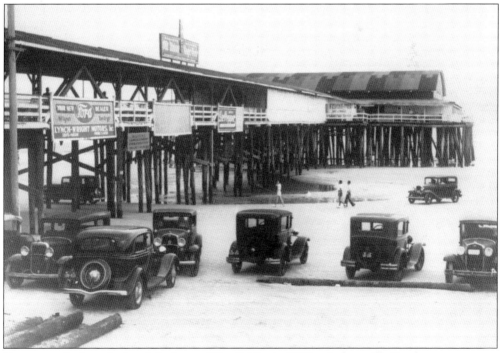

Cars are parked on the beach in front of Shad's Pier in 1933 at Jacksonville Beach.

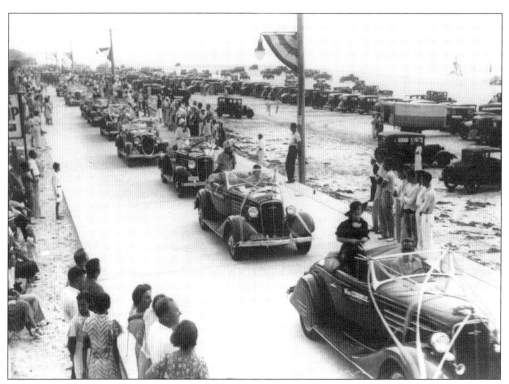

Jacksonville Beach residents and visitors celebrate the dedication of the town's seawall and ocean promenade on September 9, 1934, with a beauty pageant parade. Contestants are riding in convertibles on the boardwalk. Identified in the first car is Miss Cordele, Clarice Iwanowski Sweeting, and in the second car is an unidentified Miss Valdosta.

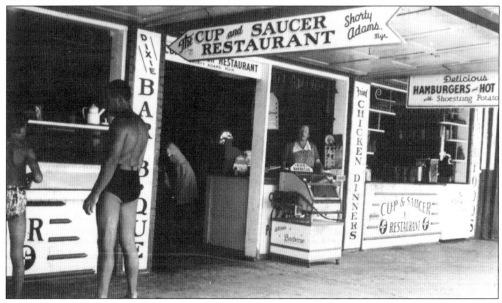

This photograph of the Jacksonville Beach boardwalk was taken around 1937. The Cup & Saucer Restaurant is on the right, with a woman identified as Mrs. Krazer standing behind the counter. The Dixie Bar-B-Que is on the left.

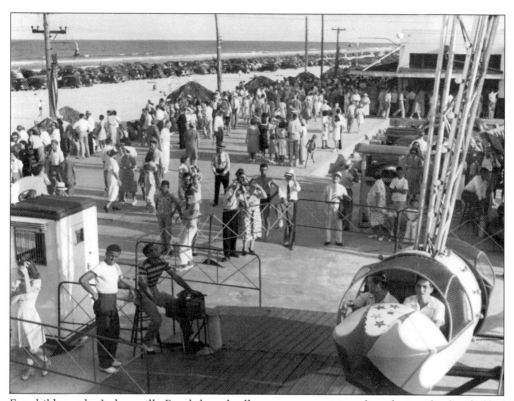

For children, the Jacksonville Beach boardwalk was a very exciting place during the first half of the 20th century. Here, crowds can be seen at the Roll-O-Plane ride in 1939.

This is a c. 1940 picture of the Jacksonville Beach roller coaster, which was located on the boardwalk. It was taken from the southeast corner of Second Avenue and First Street North.

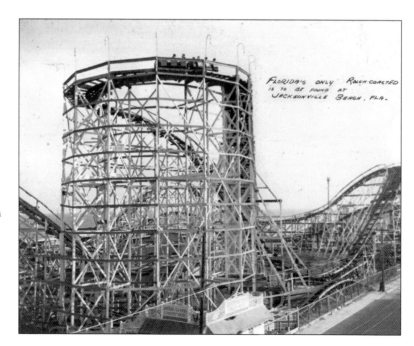

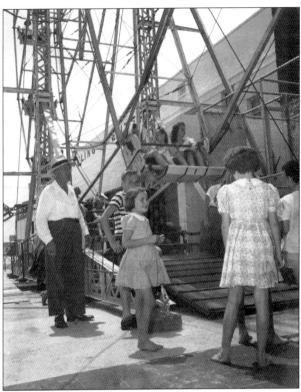

Here, people enjoy the Ferris wheel on the Jacksonville Beach boardwalk in the 1940s.

It was a long tradition to celebrate the opening of the spring and summer season. In the mid-1940s, when this photograph was taken, it was called The Welcome Parade and later the Opening of the Beaches. This photograph shows the boardwalk near First Avenue North.

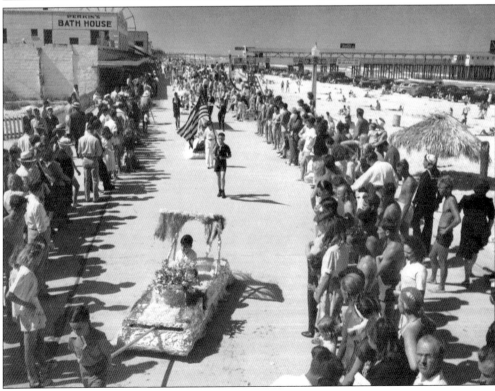

This is an aerial view of the Jacksonville Beach boardwalk looking west in 1947. Compared to photographs taken in the 1920s and 1930s, it shows how much the area had changed over the years.

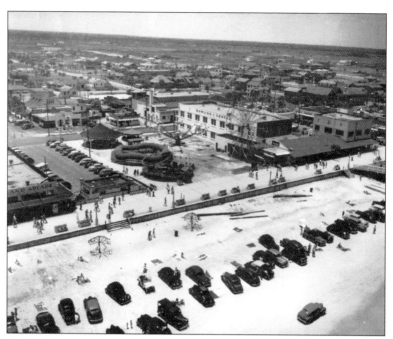

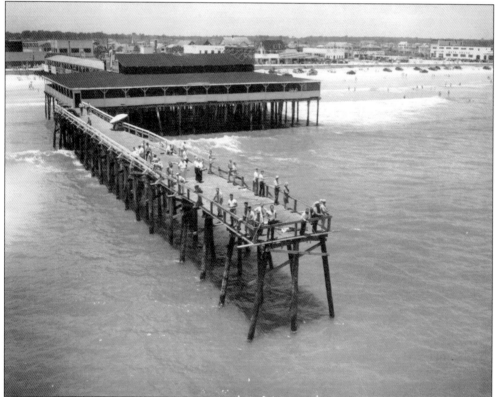

This is the Jacksonville Beach Pier around 1948. The photograph was taken from the ocean and shows damage to the end of pier from a storm. It also highlights the boardwalk, Flag Pavilion, bus station, Adkins Drugstore, and Sandpiper Bathhouse in the background.

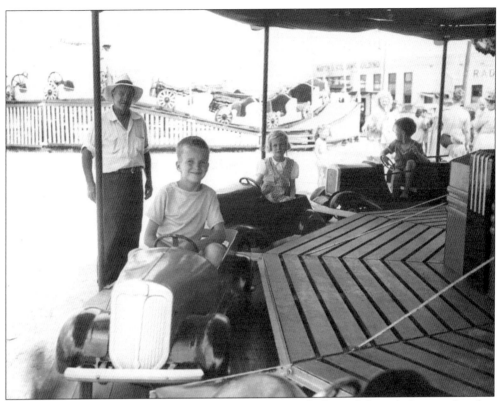

Amusements for children on the Jacksonville Beach boardwalk changed through the years, but they were always thrilling. This 1948 photograph shows the Little Car Ride, a ride for young children, at Griffen Amusement Park.

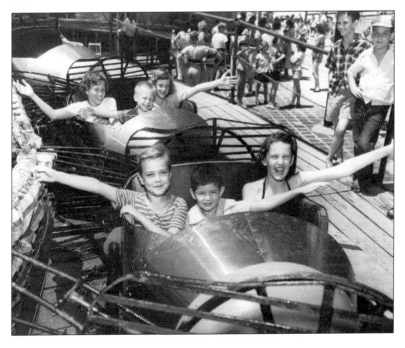

Kids are obviously having fun on a ride in the Griffen Amusement Park in the 1950s at Jacksonville Beach.

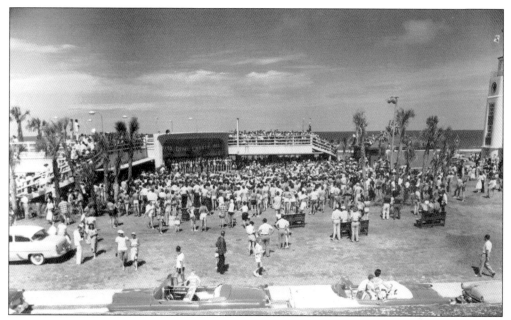

The Tourist Recreational Stage, at the oceanfront near the boardwalk, was a popular place for activities in mid-20th century Jacksonville Beach. This image shows a typical scene in 1955.

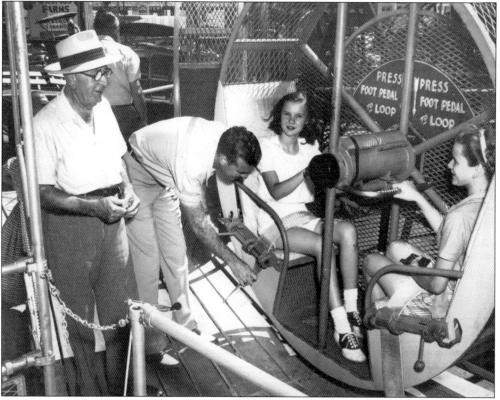

Griffen Amusement Park on the Jacksonville Beach boardwalk was long a popular spot. This photograph shows Frank Griffen Jr. and Sr. buckling in two young girls on a ride in the late 1950s.

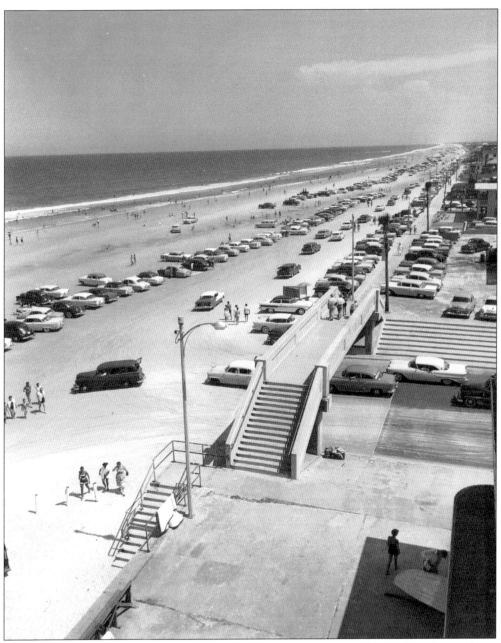

This c. 1960 photograph shows the pedestrian overpass at the foot of Beach Boulevard. Cars drove under it to reach the beach after paying a toll.

Seven

WARS

Troops from Teddy Roosevelt's Spanish-American War Rough Riders had plenty of space to pitch their tents and start a field hospital when they came to the new and wide-open town of Pablo Beach in 1898. They were from the 3rd Nebraska Volunteers and were led by three-time US presidential candidate William Jennings Bryan. They camped in rows of big white tents and used a pinewood house, built in 1890 and located on the southeast corner of Second Street and Sixth Avenue South, as their hospital.

While stationed there, soldiers practiced drills on the beach while Bryan rode horseback. Unfortunately, a yellow fever epidemic swept through the area, and the sick soldiers were laid out on the hospital's porches. According to elderly Jacksonville Beach resident Jimmy Gonzales in a newspaper article published in 1949, many died. He remembered the soldiers well.

World War I did not seem to impact Pablo Beach directly, but World War II affected many residents. Homes and businesses that faced the ocean had to extinguish lights at night to protect the coast. They realized the importance of darkening the shoreline in April 1942 when a German submarine stalked and sank the American tanker SS *Gulfamerica* off the coast of Jacksonville Beach. The Germans could easily see the tanker against the bright lights of the town. The *Gulfamerica* was destroyed and exploded into a huge ball of fire that could be seen up and down Florida's northeast coast. Hundreds of people on the Jacksonville Beach boardwalk watched the fire spread out at sea. Many of the tanker's crew perished, but others, who were thrown into the ocean, were rescued.

When World War II ended, residents celebrated in the streets.

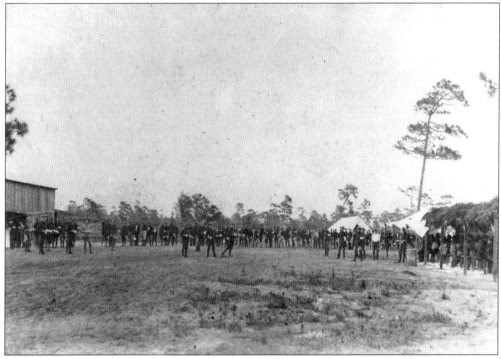

Spanish-American War soldiers drill on a field in Pablo Beach in 1898. They were from the 3rd Nebraska Volunteers, led by William Jennings Bryan, who ran for US president three times. Bryan volunteered to lead the Nebraska soldiers because he strongly supported the war. He contracted typhoid fever in Florida, however, and never saw combat.

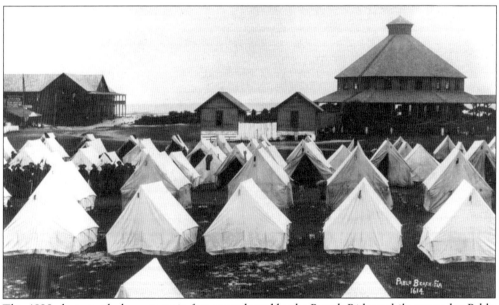

This 1898 photograph shows tents in foreground used by the Rough Riders while camped at Pablo Beach during the Spanish-American War. In the background, there are permanent buildings, including the popular oceanfront pavilion Little Coney Island (right).

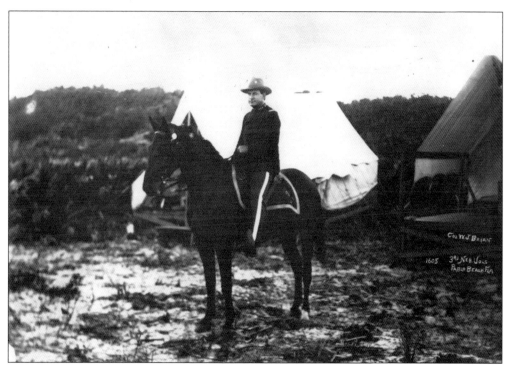

Col. William Jennings Bryan, of the 3rd Nebraska Volunteers, poses on horseback in Pablo Beach in 1898 during the Spanish-American War. Bryan, who was born on March 19, 1860, and died on July 26, 1925, was a leading American politician from the 1890s until his death. He unsuccessfully ran for president of the United States three times for the Democratic Party in 1896, 1900, and 1908. He served in Congress as a representative from Nebraska and as US secretary of state under Pres. Woodrow Wilson from 1913 to 1915.

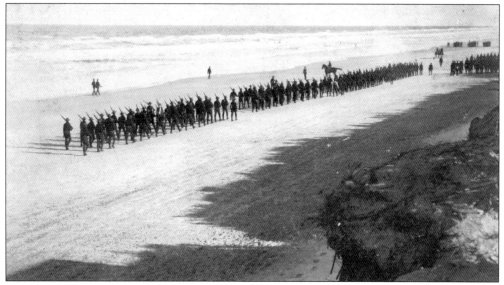

The 3rd Nebraska Volunteers drill on the beach in Pablo Beach in 1898 during the Spanish-American War.

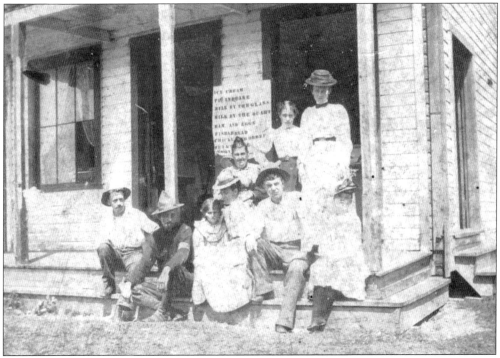

This photograph was taken at Pablo Beach at Pablo Avenue and Second Street in 1898.

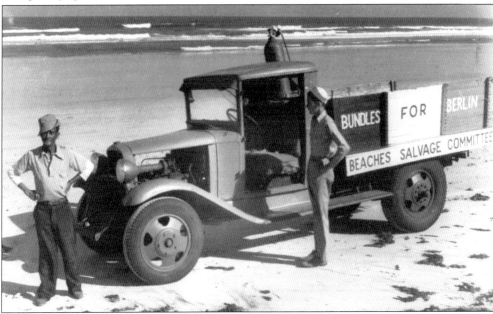

The Beaches Salvage Committee, a division of the Beaches Defense Council, was in operation during 1942 gathering scrap metal and rubber for the World War II effort. Fred Williams was chairman, and two of the members were Mr. McCue and Charles Helvenston. George Mears was chairman of the Beaches Defense Council. This picture shows the two operators: Jack Williams (right) and Oscar Bailey. The Beaches Salvage Committee terminated when both the Williams men joined the Navy.

Women from Jacksonville Beach helped the war effort in World War II, as this image shows. Members of the Duval County Chapter of the American Red Cross Motor Corps Transportation Service Beaches Unit are pictured in front of an automobile. They are, from left to right, Louise Powell, Elizabeth Hore, Alline Saunders, Estelle Cleland, and Maurine Cone. The photograph was taken on June 4, 1944.

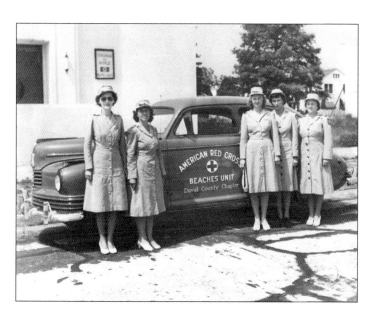

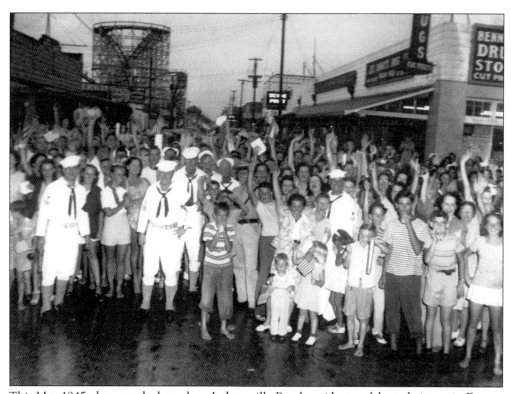

This May 1945 photograph shows how Jacksonville Beach residents celebrated victory in Europe during World War II. The streets were filled with crowds for the celebration. Some people in the crowd were sailors, while others were adults and children waving flags and making the "V" sign.

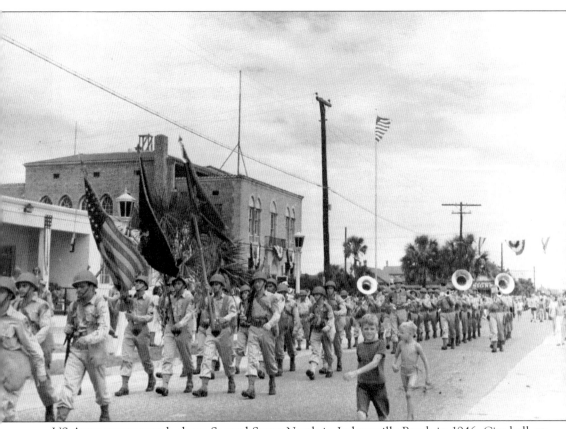

US Army troops parade down Second Street North in Jacksonville Beach in 1946. City hall, at 200 Pablo Avenue, is in the background, and the community center is on the left.

Eight

DRIVING ON THE BEACH

Automobiles were invented shortly after people founded the town that would become Jacksonville Beach, and they soon discovered the miles-long beach made a great road. It was wide, with hard-packed sand, and there was plenty of room for parking. Residents and visitors thought driving on the beach was great fun, based on photographs from the 1920s through the 1960s. On busy summer days, the beach often looked like a parking lot, with beachgoers and swimmers having fun in and around their cars. It was "the most perfect roadway, 300 to 400 feet wide—the grandest beach in the south," one advertising promotion proclaimed.

Many people drove from Jacksonville, but others came from much farther. The *Pablo Beach News* reported that on July 4, 1923, thousands of cars were parked on the beach, and that hundreds of cars with license plates from Georgia and Alabama were counted. They were able to drive to the beach "thanks to improved roads to Florida," the article stated.

People even held car races and car parades on the beach, and many longtime residents today have fond memories of the Beach Boulevard entrance onto the beach in the 1960s and 1970s, where a tollbooth was located.

Driving was banned on the beach in Jacksonville Beach in the late 1970s, and the pedestrian overpass at the foot of Beach Boulevard was dismantled. The beaches are still wide, with hard-packed sand—but for people and bicycles only.

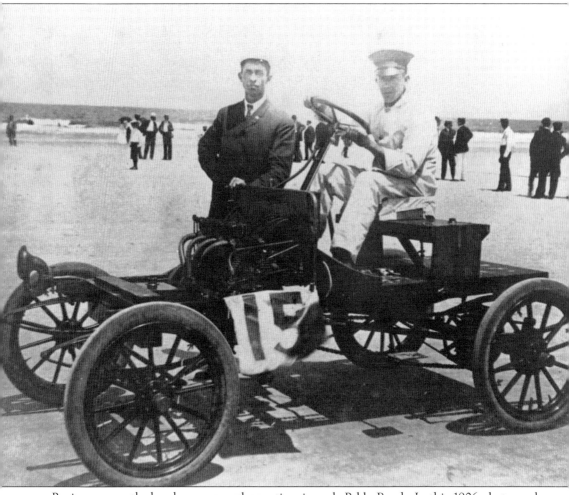

Racing cars on the beach was a popular pastime in early Pablo Beach. In this 1906 photograph, John E. Gilbert (driver) and an unidentified man are pictured with a four-cylinder Franklin no. 15. Gilbert won a silver trophy for racing at 80 miles per hour.

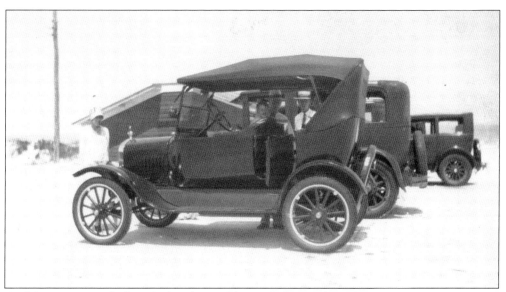

Model T cars are parked on the beach in Pablo Beach during the early 1900s.

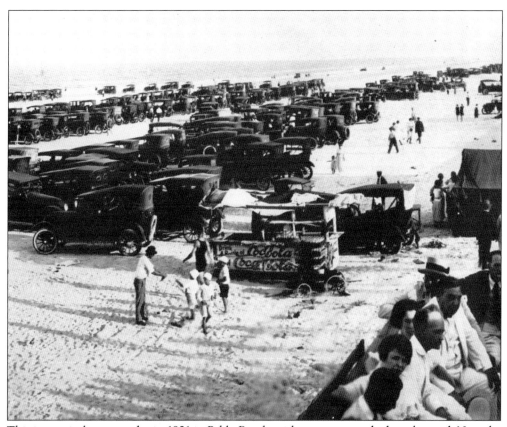

This is a typical summer day in 1921 in Pablo Beach, with many cars parked on the sand. Note the Coca-Cola stand in the center of the photograph, as well as ladies and gentlemen sitting on a bench on the boardwalk in the foreground. The photograph was taken on September 5, 1921.

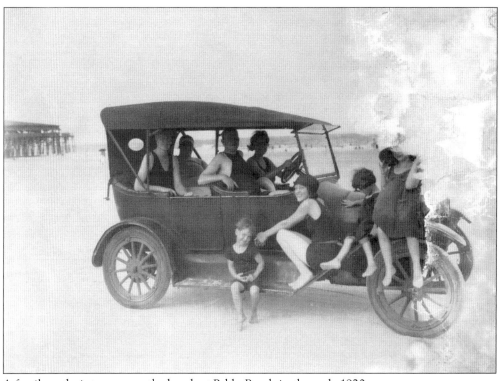

A family packs into a car on the beach at Pablo Beach in the early 1920s.

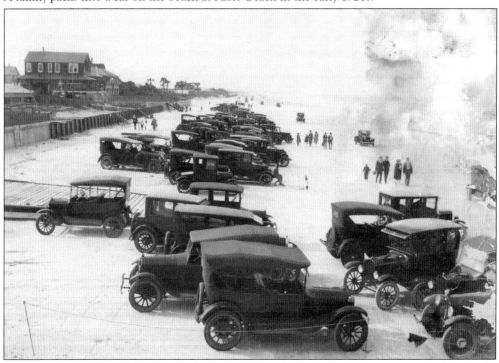

Cars are seen on the beach in the 1920s. This image shows the wooden ramp to the beach, the wooden seawall, and stairs to the beach.

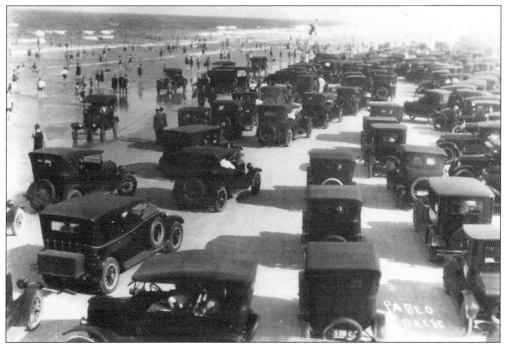

Many black cars pack the beach in the 1920s at Jacksonville Beach. People thought it was fun to sunbathe and swim amongst automobiles.

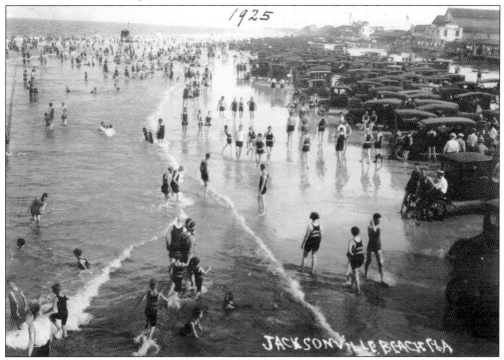

This photograph shows Jacksonville Beach at high tide on a summer day in 1925. Lines of cars are parked in front of the boardwalk. Perkins Bathhouse can be seen on the right, and the American Red Cross Volunteer Lifeguard Station is in the background.

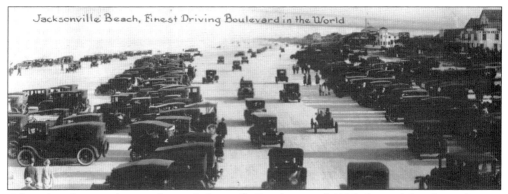

When this photograph was taken at Jacksonville Beach around 1925, the city's beach was known as the "finest driving boulevard in the world."

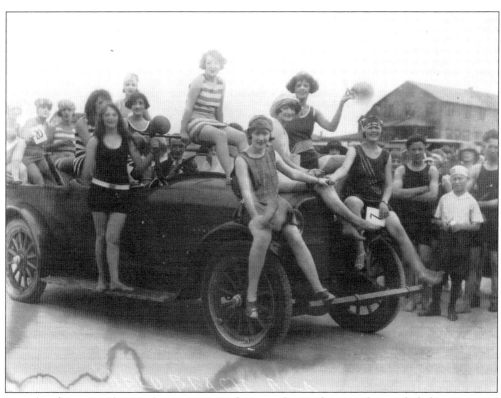

Here, beachgoers are having fun in 1929. At the time, fun in the sun often included cars.

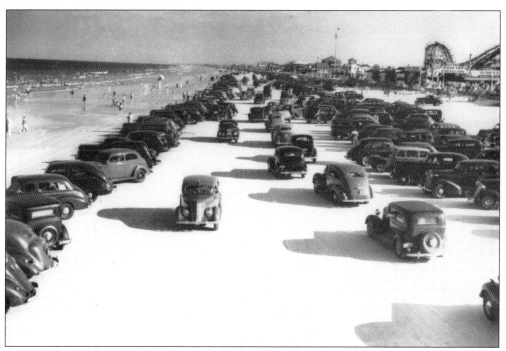

In this 1933 photograph, many cars are parked on the beach at Jacksonville Beach in front of the pier. Some structures on the boardwalk include the Ocean View Pavilion, the American Red Cross Volunteer Lifeguard Station, the roller coaster, and Martin's Grill.

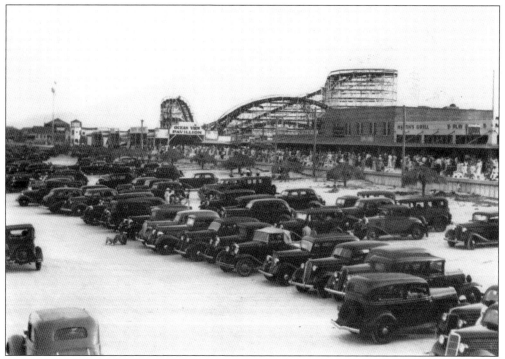

Rows of cars pack the beach at Jacksonville Beach in 1933. Parking was close and plentiful for those who wanted to enjoy a day in the ocean and on the boardwalk.

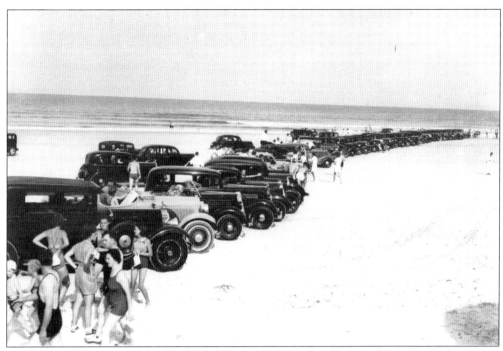

Cars line the beach in a row in June 1936. The parked vehicles illustrate how wide the beach was at low tide.

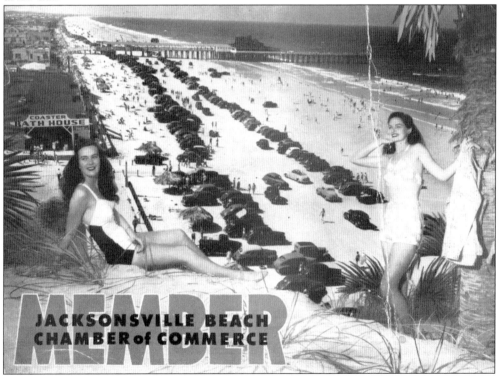

Selling Jacksonville Beach with bathing beauties was the rage in the 1940s. This was a typical photograph used with advertisements or postcards. Note the cars on the beach.

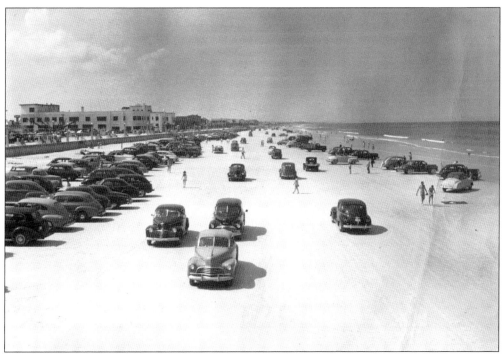

In this April 1949 photograph, cars are parked on the beach by the Sandpiper Bathhouse and Hotel with the Casa Marina Hotel in the background. It is low tide.

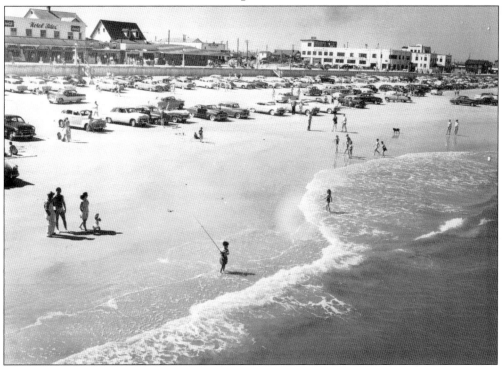

This photograph shows the beach on a typical day in 1950. Cars are parked on the beach near Zapf House and the Hotel Tides at the boardwalk.

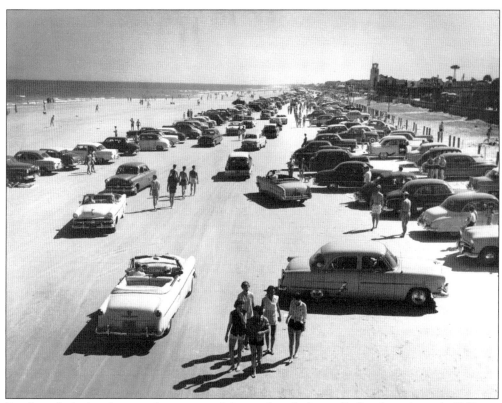

People pack the beach to watch an automobile parade at Jacksonville Beach in the early 1950s.

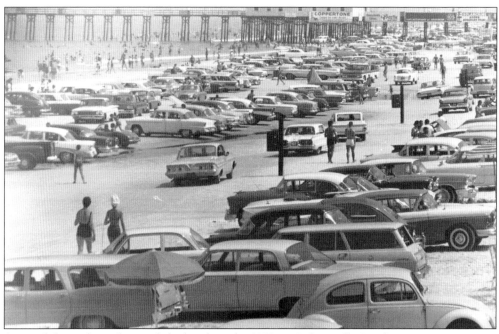

Automobiles and people crowd the beach in the 1950s at Jacksonville Beach.

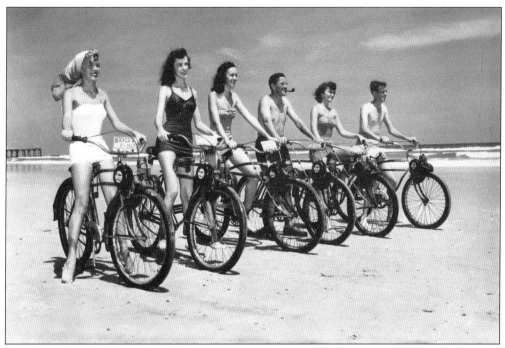

The beach in Jacksonville Beach was not just for cars, the hard-packed sand was, and still is, also perfect for bicycles. Here, young adults ride bikes in the mid-20th century; note the license plates.

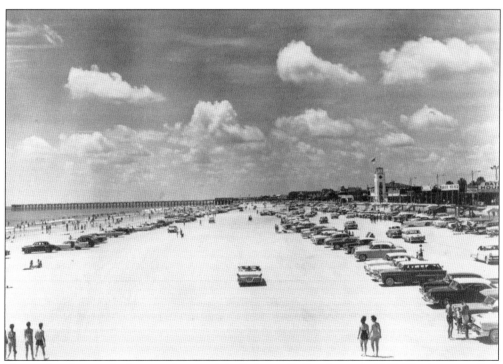

This is a beach scene looking south toward the Jacksonville Beach pier in 1962. The American Red Cross Volunteer Lifeguard Station is midway on right. There are many cars and bathers.

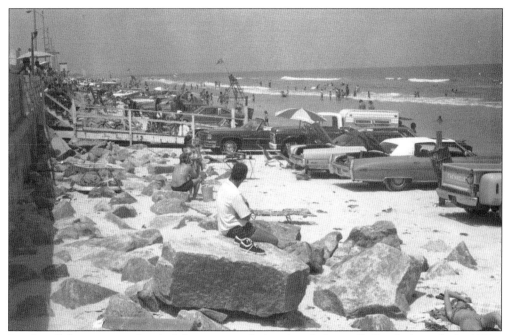

People still drove onto and parked their cars on the beach in Jacksonville Beach through the 1970s, as this photograph depicts. Bathers are seen sitting on the beach on the granite rocks that were present at the time.

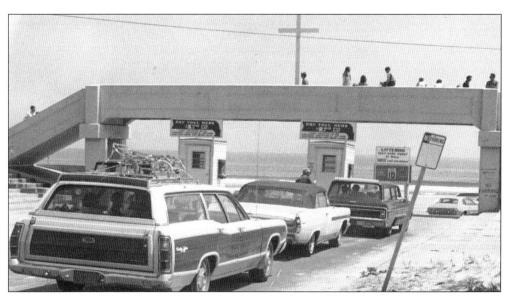

In the 1970s, beachgoers with their cars paid $1 per day at the tollbooth at the end of Beach Boulevard to be allowed access to the beach. Pedestrians crossed safely on the pedestrian ramp.

Nine

BUILDINGS AND BUSINESSES

Storms, fires, and modernization changed the appearance of Jacksonville Beach through the years, and many longtime businesses and iconic buildings exist now only in photographs. But, one of the oldest buildings associated with the Murray Hall Hotel survived the 1890 fire that destroyed the resort and still exists today. The building is a small, white wooden chapel that now sits on the grounds of the Beaches Museum & History Park. It was built by Murray Hall Hotel guests for Sunday services and was later moved about 11 blocks north to serve as the St. Paul's by the Sea Episcopal Church. After the church constructed a larger building, the chapel was moved to the grounds of Beaches Chapel in Neptune Beach and was just recently relocated to the museum and history park.

Another important building, the Casa Marina Hotel, also survives and is now a popular Historic Hotels of America destination. The Mediterranean Revival–style building with a tile roof was built in 1925 and, in the mid-20th century, was turned into an apartment building. It has been restored to its Roaring Twenties glory, minus the pool.

Some important buildings and businesses that no longer exist include the Ocean View Hotel, which opened in 1914; the Sandpiper Hotel and pool, which opened in 1920; the Miller & Rose boardwalk amusement park, which also opened in 1920; Arnot's Bakery, which opened in 1938; the Flag Pavilion, which first opened in 1966; and the old city hall.

The Perkins House, the Adams House, and Palmetto Lodge were all popular boardinghouses during the city's heyday as the world's finest beach that were destroyed by fire.

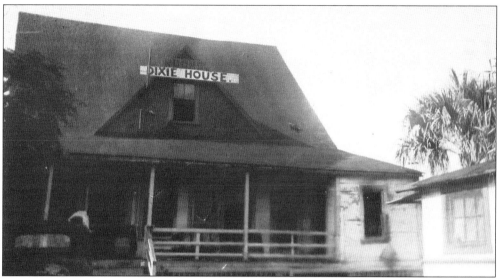

After Pablo Beach pioneers William and Eleanor Scull moved to the beach in the mid-1880s, they built this house. They lived in a tent in 1884 and moved into "Dixie House" in 1885.

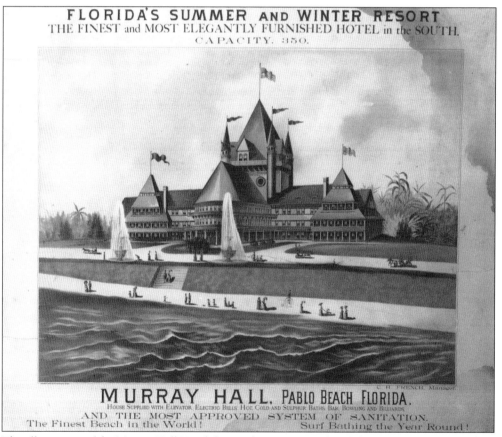

FLORIDA'S SUMMER AND WINTER RESORT
THE FINEST and MOST ELEGANTLY FURNISHED HOTEL in the SOUTH.
CAPACITY. 350.

MURRAY HALL. PABLO BEACH FLORIDA.
House Supplied with Elevator. Electric Bells, Hot, Cold and Sulphur Baths, Bar, Bowling and Billiards.
AND THE MOST APPROVED SYSTEM OF SANITATION.
The Finest Beach in the World! Surf Bathing the Year Round!

This illustration of the Murray Hall Hotel shows why it was considered the finest hotel in the South when it was completed in 1886 in Pablo Beach. It was destroyed by fire in 1890.

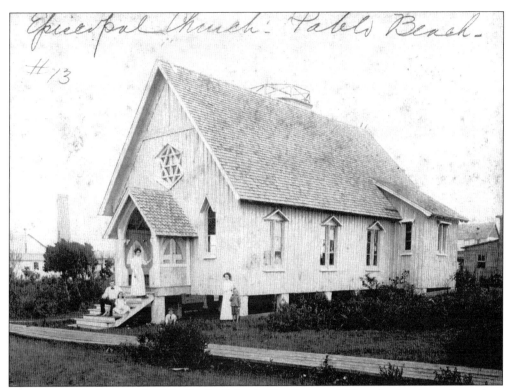

This is an 1889 photograph of the St. Paul's by the Sea Episcopal Chapel, when it was located on the oceanfront between Third and Fourth Avenues South in Pablo Beach. It was built by visitors of the Murray Hall Hotel for their Sunday services.

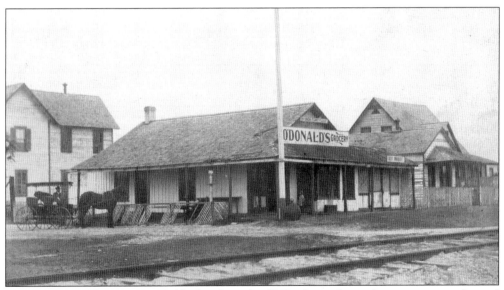

This is O'Donald Grocery in Pablo Beach in the 1890s. It was located on a corner on Second Street. Note the railroad tracks, dirt road, and horse and buggy.

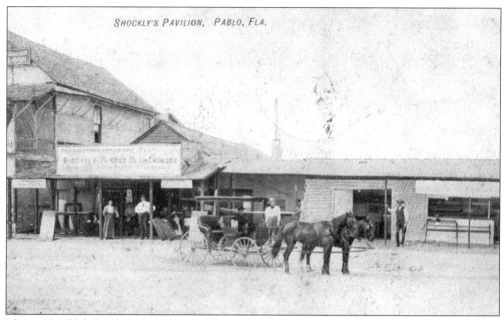

This is Shockly's Pavilion in 1907 at Pablo Beach. Note the horse and buggy and dirt road. The sign on the building reads, "Shockly's Famous Clam Chowder."

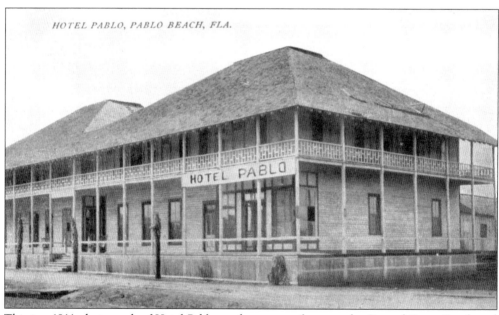

This is a 1911 photograph of Hotel Pablo, at the corner of present-day Second Street South and Second Avenue South. The image was made into a postcard to draw tourists to Pablo Beach.

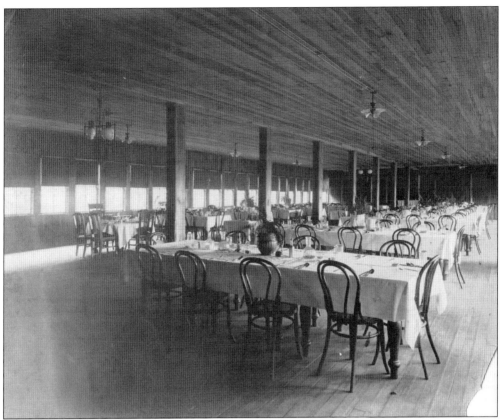

This is a c. 1915 view of the dining room of the Ocean View Hotel.

Perkins Bathhouse did a booming business in 1918 Pablo Beach when this photograph was taken. The sign states, "Check Valuables" and "Ring Bell for Suits."

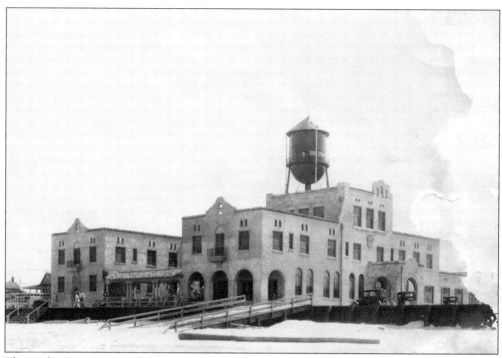

This is the Casa Marina Hotel in 1926, a year after it was built in Jacksonville Beach. Its water tower can be seen in the background. The water tower no longer exists, but the Casa Marina looks much the same today as it did when it was built.

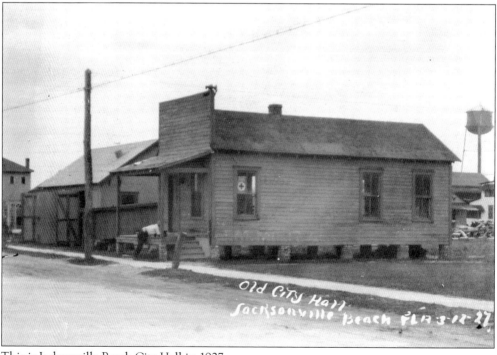

This is Jacksonville Beach City Hall in 1927.

"Ma" Nichols stands at the entrance to Nichols Court at Jacksonville Beach in 1928. It was one of many hotels and lodges that catered to tourist families.

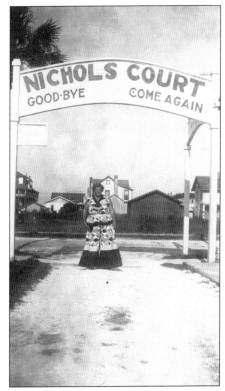

Troop No. 40 was the first Boy Scout troop at Jacksonville Beach. It was organized in 1921, officially charted in March 1925, and sponsored by the City of Pablo Beach (later Jacksonville Beach). The troop met in city hall, shown in this photograph taken on June 22, 1931. City hall, an imposing Mediterranean Revival–style structure, was located at 200 Pablo Avenue until 1964, when the building was demolished.

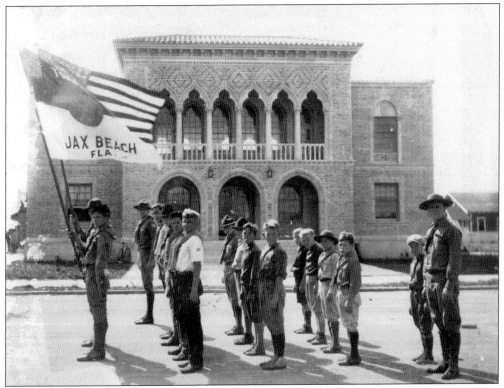

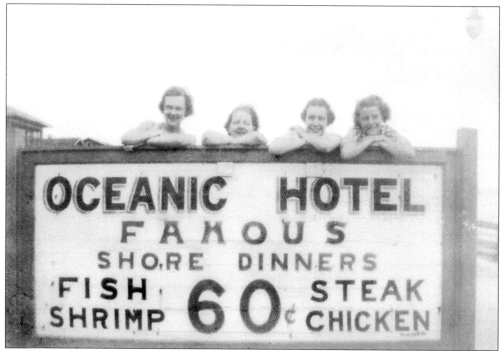

Four young women lean on the sign to the Oceanic Hotel in 1936 at Jacksonville Beach. The oceanfront hotel was a popular establishment in town for many years.

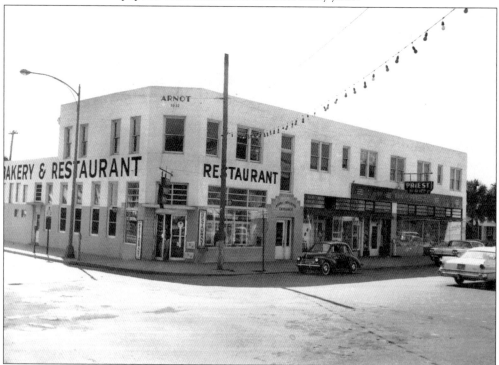

Arnot Bakery and Restaurant, shown here in 1958, was a popular business in Jacksonville Beach. It was located at First Street and Pablo Avenue. The building was erected in 1937.

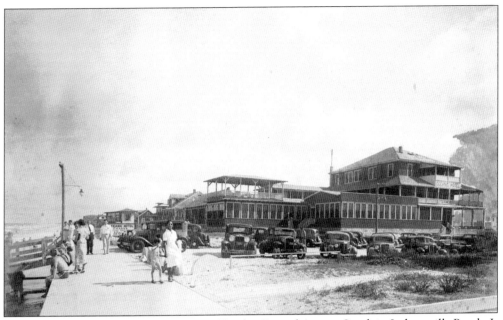

This is a 1938 photograph of the Oceanic Hotel at Second Avenue South in Jacksonville Beach. It was a favorite place to stay for many tourists.

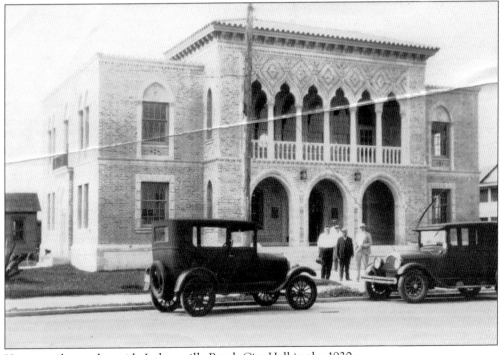

Here, people stand outside Jacksonville Beach City Hall in the 1930s.

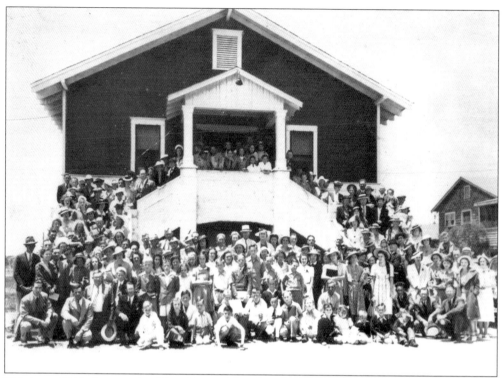

This is a c. 1940 photograph of First Baptist Church and its many members in Jacksonville Beach.

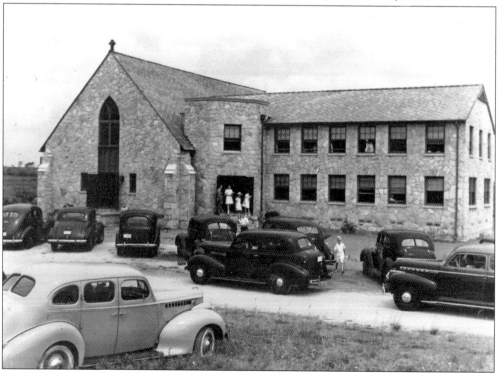

Beach Methodist Church is pictured in Jacksonville Beach in 1941 or 1942.

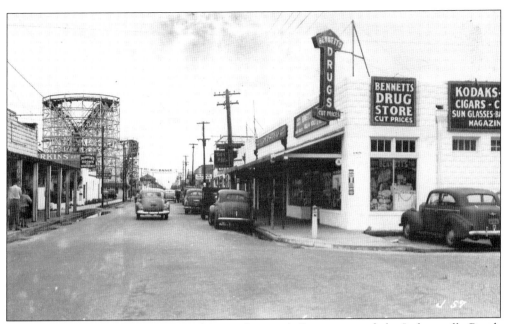

This is First Street North in 1943, showing Bennett's Drugstore and the Jacksonville Beach roller coaster.

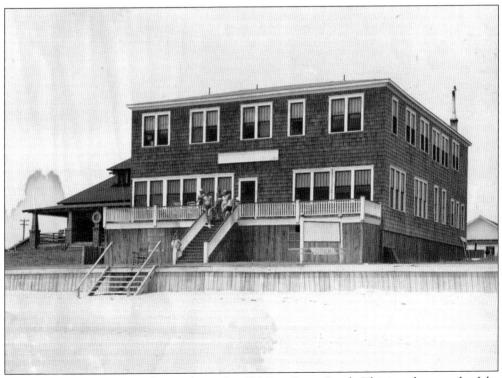

The oceanfront Weimers Lodge was located at 509 First Street South. This is a photograph of the popular lodge in 1944.

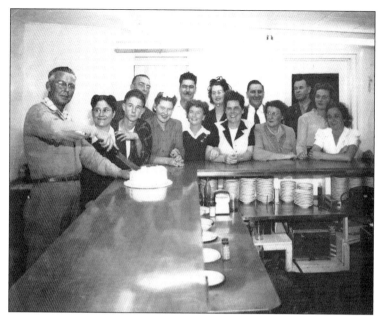

The staff of Gufford's Chowder House on First Street North is pictured around 1946 in Jacksonville Beach. They are, from left to right, William S. Gufford Sr., Eva Mae Gufford, William S. Gufford Jr., "Red" Yates, Mrs. Myrtle Hancock, Mr. Chichester, Ann Chichester, unidentified, Louise Yates, unidentified, Marge Scott, Brig. Gen. Dough Scott, Mrs. Evelyn Brown, and Annie Siefert.

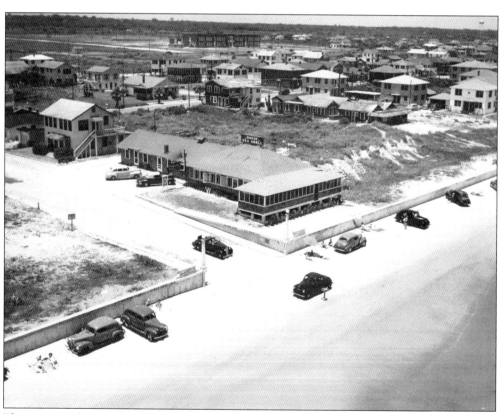

This is an aerial view of Davis' Sea Shell; note Fletcher High School in background. The photograph was likely taken in the mid-20th century.

This is a photograph of the interior of the First Missionary Baptist Church, located at 810 Third Avenue South in Jacksonville Beach. The photograph was likely taken in mid-20th century.

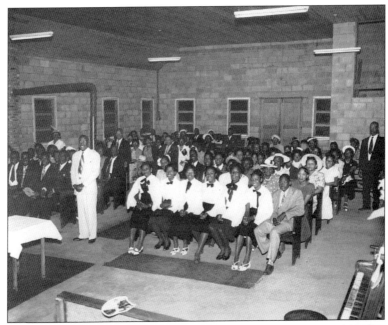

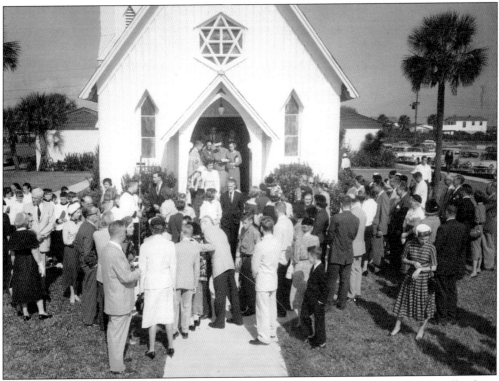

The congregation of St. Paul's by-the-Sea Episcopal Church gathers outside their small, white, Gothic Revival–style chapel in 1955. The chapel was built in 1887 and originally sat on Second Street South and Second Avenue South. The church later built a larger sanctuary and sold and moved the chapel to Neptune Beach. It was recently sold to the Beaches Museum & History Park and moved to Pablo Historical Park.

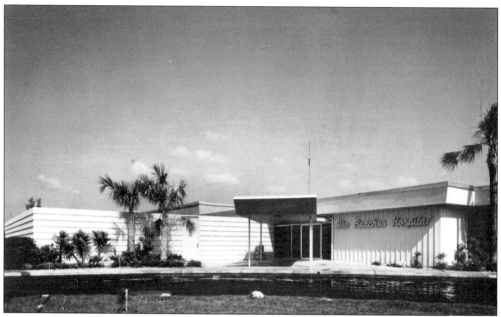

The Beaches Hospital, located at 1430 Sixteenth Avenue South, is seen around 1970.

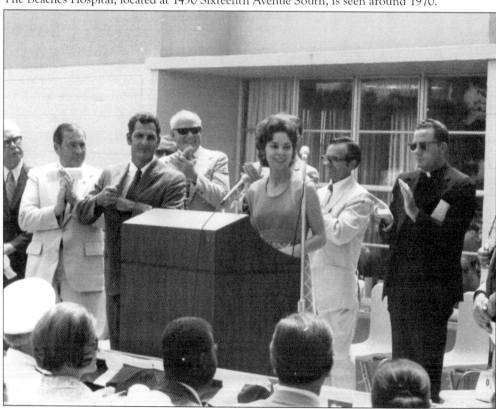

Julie Nixon Eisenhower, daughter of Pres. Richard Nixon, speaks at the dedication to Pablo Towers on Friday, August 17, 1973. Pablo Towers was built in the approximate location of where Jacksonville Beach School No. 50 was once located. It is a senior citizen apartment community.

Ten

BEACH SCENES

When people first started going to the beach for recreation, they dressed in clothes that covered their bodies—from head to toe. The first bathing suits were very modest, with women wearing hats, hose, beach shoes, and outfits that covered much of their arms and legs. In the early 1900s, one-piece woolen bathing suits evolved, which were worn by men, women, and children. People thought they were wonderful, according to newspaper fashion columnists of the time. "For this summer, there are bathing suits and bathing suits in which we may go down to the sea or the pool," wrote one female columnist for the *Pablo Beach News* in 1922. "Wool jersey is the excellent medium chosen for making many attractive suits." There are also "those of gingham to be reckoned with. Those are made of checked ginghams, and are in a class by themselves."

Photographs of Pablo Beach in the early 1920s mirror reports in its community newspaper of how the beach looked on sunny summer days. In April 1923, at the opening of the summer season, "nowhere in the world is there a beach like Pablo Beach," a reporter stated. "It's thronged by thousands of bathers in full enjoyment of the delights of a dip in the briny deep. The young and the old gambol on the pure white sands at low or middle tide, when the beach offers 300 to 400 feet of playground."

That scene continued through the years into the present, with mainly only the bathing attire changing—not the fun.

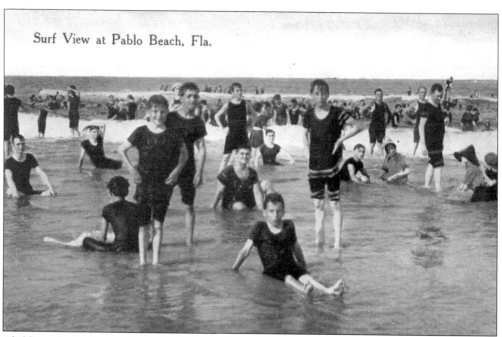

Surf View at Pablo Beach, Fla.

Children play in the surf in Pablo Beach in the early 1900s. This photograph shows what bathing suits looked like at the turn of the 20th century. The photograph was used on a postcard.

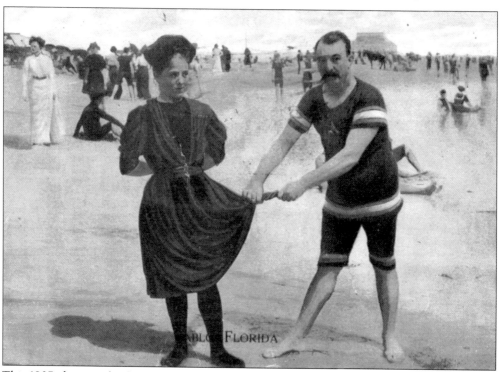

This 1907 photograph of a man squeezing water from a woman's wool swim dress on the beach in Pablo Beach was used on a postcard. She is wearing stockings, swim shoes, a swim dress, and bath hat, which were very fashionable at the time.

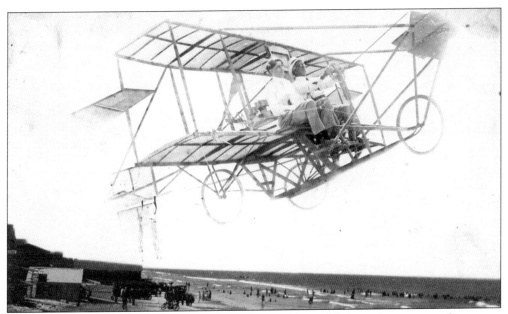

A biplane sails over Pablo Beach in 1913. The photograph was likely used in a postcard.

A group of children visits Pablo Beach around 1916 and appear to be having a picnic.

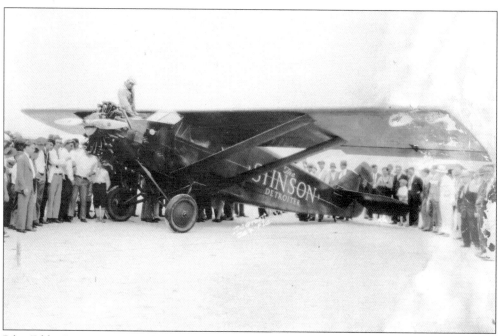

Pilot Eddie Stinson gets into his airplane as a crowd gathers around him on March 30, 1928, in Jacksonville Beach. They came to see him take off from the beach to perform an endurance flight, which lasted 53 hours and 35 minutes. Not only were cars a common sight on the town's beaches in the early days, but airplanes as well.

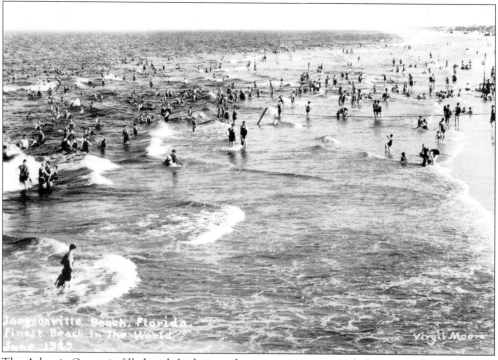

The Atlantic Ocean is filled with bathers and swimmers on a crowded summer day in 1929 in Jacksonville Beach, the world's finest beach.

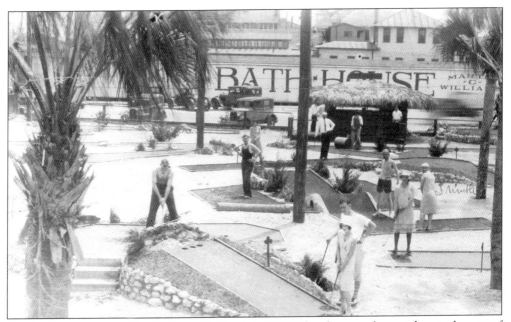

People play miniature golf in Jacksonville Beach in 1929. The photograph was taken in the area of present-day Third Avenue North and First Street. Note the sign for the bathhouse.

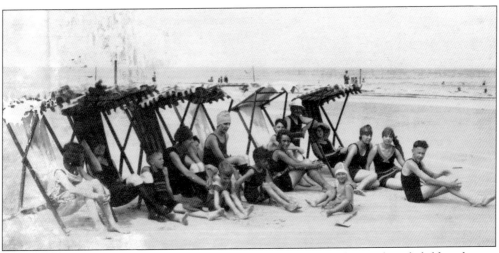

Women, including two identified as Margaret Williams and Myrtle Hood, and children lounge in beach chairs in 1931 at Jacksonville Beach. The photograph appeared in the *Jacksonville Beach News* on June 22, 1931.

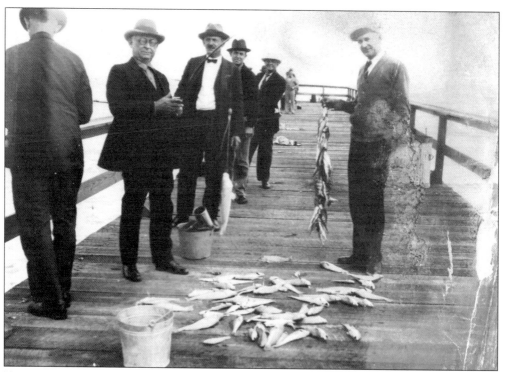

Here, men wearing suits and ties fish on the Jacksonville Beach pier in the 1930s.

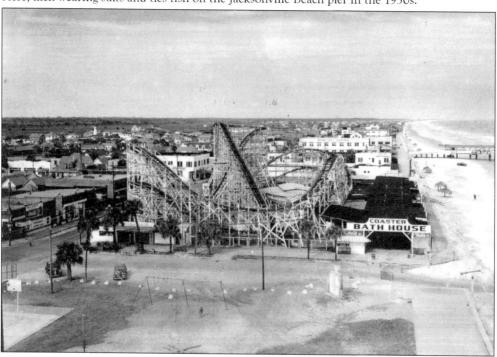

This is an aerial view of the shoreline of Jacksonville Beach in the early 1940s. It was probably taken from the top of the American Red Cross Volunteer Lifeguard Station at the foot of Beach Boulevard. The roller coaster and Coaster Bathhouse are in the center.

This is a 1947 wide-angle view of Griffen Amusement Park at the boardwalk. It includes the Martin Williams Building and many bathers. The boardwalk, at that point, was cement rather than wood.

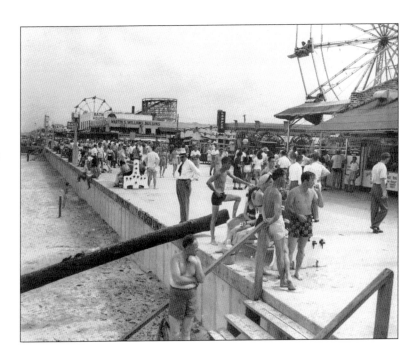

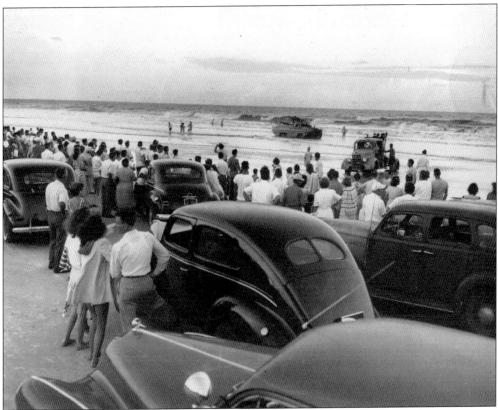

Spectators line the beach in the late 1940s to watch an armed services' amphibious landing demonstration at Jacksonville Beach.

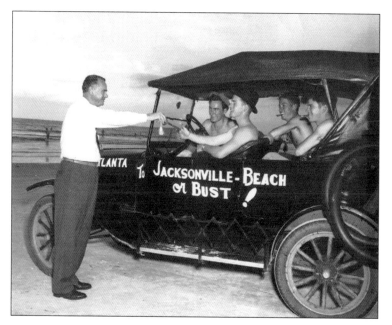

This photograph was created for an ad for Jacksonville Beach in 1947. It appears that it was created to appeal to tourists from Atlanta, Georgia.

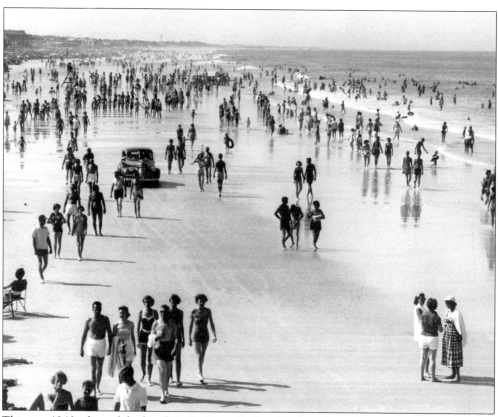

This is a 1940s shot of the beach in Jacksonville Beach taken from the pier looking north on a summer day.

These bathing beauties on the beach in 1947 are, from left to right, Marcy Dillon (later Mrs. J.B. Griffin), Nina Jo Dillon (later Mrs. Lewis Christman Jr.), and Nettinell Mickler, who won Miss Jacksonville Beach in 1946.

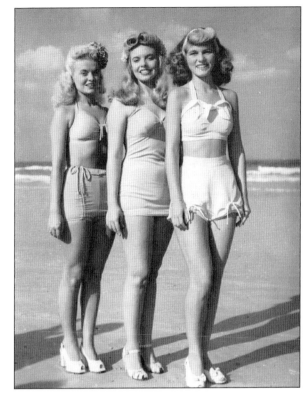

Bathing beauties lie down on the sand in Jacksonville Beach to create a clock formation in the 1950s. The beach was a popular spot to photograph bathing beauties, especially in the 1940s and 1950s.

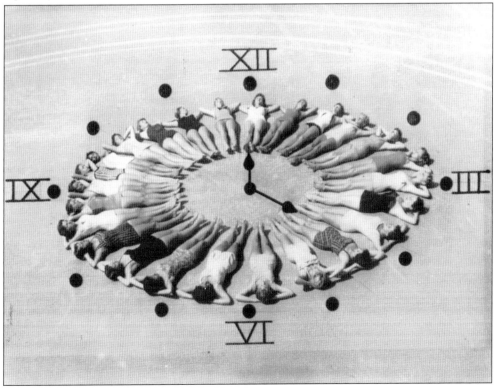

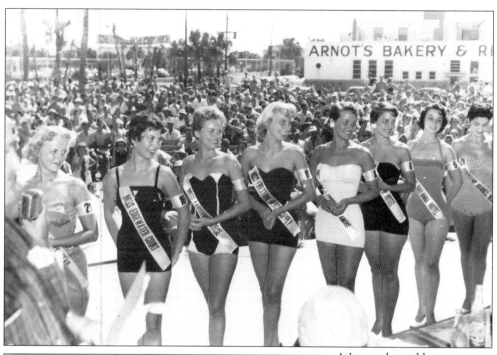

A Jaycees-hosted beauty contest takes place in Jacksonville Beach in the 1950s. The beauties were sponsored by area businesses.

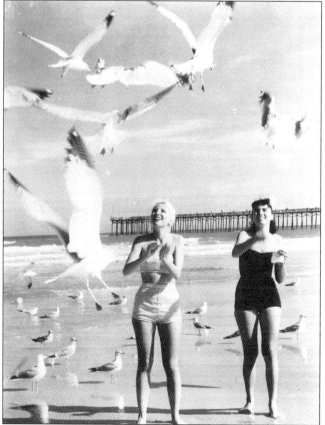

Girls feed gulls in 1964 with the Jacksonville Beach pier in the background. This photograph was published in the *Florida Times-Union* newspaper.

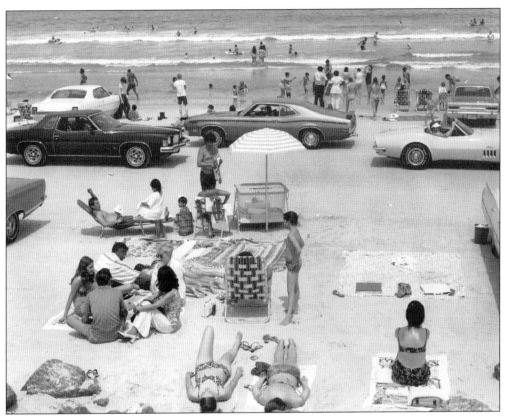

People enjoy the beach on a nice summer day in the 1960s. Some parked their cars close to the ocean and set up beach umbrellas there as well.

Young babies participate in a Jacksonville Beach baby's race on the beach in the 1970s. Baby races were popular at that time.

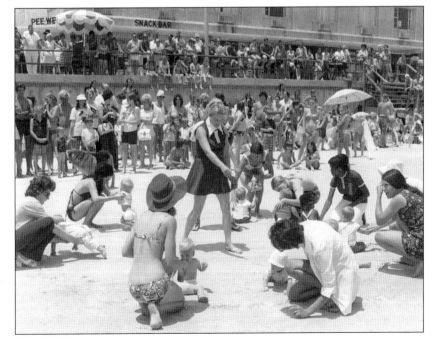

DISCOVER THOUSANDS OF LOCAL HISTORY BOOKS FEATURING MILLIONS OF VINTAGE IMAGES

Arcadia Publishing, the leading local history publisher in the United States, is committed to making history accessible and meaningful through publishing books that celebrate and preserve the heritage of America's people and places.

Find more books like this at
www.arcadiapublishing.com

Search for your hometown history, your old
stomping grounds, and even your favorite sports team.